Using Slips

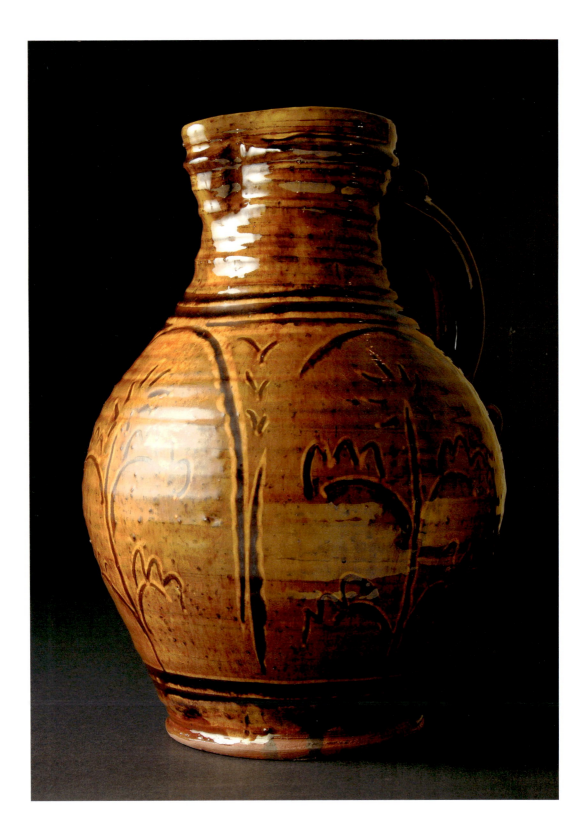

Techniques Using Slips

John Mathieson

A & C Black • London

University of Pennsylvania Press • Philadelphia

For Esmé, Mark and Sarah
and my brother Paul

First published in Great Britain in 2010
A&C Black Publishers Limited
36 Soho Square
London W1D 3QY
www.acblack.com

ISBN: 978-14081-0626-6

Published simultaneously in the USA by
University of Pennsylvania Press
3905 Spruce Street
Philadelphia, Pennsylvania 19104-4112

ISBN: 978-0-8122-2117-6

Copyright © John Mathieson 2010

CIP Catalogue records for this book are available
from the British Library and the US Library of
Congress.

Typeset in 10.5 on 13pt Celeste

Book design by Susan McIntyre
Cover design by Sutchinda Thompson
Commissioning editor: Alison Stace

Printed and bound in China.

A&C Black uses paper produced with elemental
chlorine-free pulp, harvested from managed
sustainable forests.

Frontispiece: Jug by Doug Fitch (see p.84). PHOTOGRAPH BY JOHNNY THOMPSON.
Title page: Square dish by John Pollex (see p.92) (29 x 29 cm/11½ x 11½ in.). PHOTOGRAPH BY
JOHN POLLEX.

Contents

Acknowledgements

My thanks go to my wife Esmé, and to our children Mark and Sarah, for being there, and for all their help and guidance and support; to potters worldwide who contributed so generously to this book; Andy McInnes for his continued friendship, he really is one of the good guys; David Binch of Oakwood Ceramics for his friendship, and for all his assistance with photographs; John Edgeler for taking me further into the world of Winchcombe pots; Jay Goldmark of Goldmark Art for permission to use his photographs of Clive Bowen's work; Frank and Janet Hamer for permission to quote from *The Potter's Dictionary of Materials and Techniques*; Alison Marks at Northampton Museums and Art Gallery; and my long-time buddy Keith Hutchison, still there at the end of an e-mail after all these years.

My editor Alison Stace is everything a good editor should be, offering insight, a different perspective and the right amount of support – thank you.

This book was written to the music of Dave Domone, Bob Dylan, Robert Johnson, Paul Mathieson, Tom Rush and John Stewart – music with the bark still on.

Tea caddy by Michael Cardew, Winchcombe, 1926. Sgraffito with iron oxide brushwork. PHOTOGRAPH BY JOHN MATHIESON, COURTESY OF COTSWOLDS LIVING PUBLICATIONS.

Introduction

Slip is simply clay with sufficient water added to convert it from a solid to a liquid. Studio potters use it to coat the clay body (partially or completely) in order to produce different colours, and to create different surface textures. In addition, some potters have borrowed from industrial techniques and use plaster moulds to make a variety of forms using **slipcasting** – pouring slip into plaster moulds to create repeat forms (see glossary). This is a specialist area which a few studio potters have explored extensively (see the work of Sasha Wardell and David Cooke).

The terms **vitreous slip** and **engobe** are often used interchangeably. In the strictest meaning of the term, a vitreous slip is made from natural clay which begins to melt before the maximum temperature has been reached in the kiln. Two classic examples are Fremington clay from North Devon, which starts to vitrify at around 1100°C (2012°F), and Albany slip from New York State, which makes a glaze at 1280°C (2336°F) without further additions. An engobe is a slip that contains other materials, which have usually been added to lower the melting point in order to produce various colours and textures, and/or to increase adhesion.

Terra sigillata is made by mixing slip, allowing it to settle, siphoning off the top layer, and repeating the process several times. The result is a slip composed of extremely fine particles, so fine it resembles a semi-matt glaze on the fired pot.

Slipware is a term traditionally applied to earthenware, which is decorated with slip and fired to 1050–1125°C (1922–2057°F), usually with a lead glaze, and frequently giving stunning colours (see Clive Bowen's work).

I use the word **pot** throughout the book as a shorthand method of referring to any object made from clay.

Vase by John Mathieson, reduced stoneware with sgraffito through porcelain slip under an ash glaze (h. 8 cm/3 in.). PHOTOGRAPH BY JOHN MATHIESON.

Flask (h. 19 cm/48 in.) made by Kabyle potters, Algeria, and remarkably similar to pre-Columbian pots from South America. Purchased in 1889, Algiers. Courtesy of Northampton Museums and Art Gallery. Photograph by John Mathieson.

1 A Selected History of Using Slip

It is not possible within the scope of this book (which is designed to be a practical guide) to provide a comprehensive history of the use of slips in ceramics. Instead, this is a personal selection of some of the high points of slip usage, by potters from different cultures; it is not a linear time line, nor is it exhaustive. For your own further research, use the bibliography at the end of the book, and of course there is always Google.

The first use of 'coloured earths' (ochre, sienna and umber, which are clay earth pigments, naturally occurring oxides and charcoal) were in the hand silhouettes and paintings made by early man in caves and on rock faces. With the exception of charcoal, these same materials were used when people started decorating pots with slip. At a basic level, if a light-firing clay occurred in the same area as a dark clay, it could be used for decoration; by mixing the two, a third colour could also be achieved. Incorporating natural mineral deposits into light-firing clay will create other colours, while in dark clay such additions will make it go darker still. An enquiring mind linked to some serendipitous experiments could result in the development of a ceramic palette reflecting the geology of the area. Traditional pots from New Mexico are a classic example of this.

Until relatively recently potters had to rely on materials from their own locality, and almost by definition had to be resourceful in finding them. Later, materials were transported long distances (in the UK by barge, using the canal system).

Today, potters can get virtually everything they need from one catalogue, often with next-day delivery. The materials themselves may come from far away – I have clay in my workshop that incorporates ingredients from Australia and New Zealand. However, it can be both exciting and stimulating to explore the area in which you live to find clays and other minerals, and it can add to the individuality of your work (look at *Glazes From Natural Sources* by Brian Sutherland if you wish to take this further – see details in the Bibliography.)

Light-firing clays are less common than dark clays, and potentially more precious, and so tend to be used for decoration rather than for creating pots. In the area where I live (Northampton, UK) clay has been used since the Iron Age, and half a mile from my house lie the buried remains of a Roman kiln. There is a metre-thick seam of blue-black clay, extending in all directions for many miles, which fires dark red at 1150°C (2100°F); it throws well, but is the greasiest clay I've ever handled. The local museum houses many examples of medieval and other period slipware made using this clay, to which sand and broken shells were often added to improve both throwing and resistance to thermal shock.

Roman pottery frequently employed *terra sigillata*, which involved coating the pot with a very fine slip. Two thousand years later, pots from this era still retain this semi-gloss finish. Greek potters combined the use of slips with a complicated firing process to enhance

Pots on sale in Pisac market, Peru, 2008.
PHOTO BY ANDY MCINNES.

the decoration. I have a press-moulded pig, once a child's rattle, which was excavated at Pompeii and still has traces of white slip.

Perhaps the finest unglazed, slip-decorated ceramics ever produced are the pre-Columbian terracotta pieces from both North and South America. Handbuilt, often with modelled figures or animals, and burnished after decorating with coloured slips, they depict scenes from everyday life, and use abstract patterns, frequently on the same pot. This tradition continues today; the San Ildefonso pueblo in New Mexico (which was visited in 1952 by Bernard Leach and Shoji Hamada) is rightly famous for the quality of the work made there by Maria Martinez and her descendants.

Inevitably, once a society had discovered the technology, these wares were superseded by glazed ceramics. Hardwearing, easier to clean, less porous, and with a finish that enhanced and enlivened the surface of the pot whether plain or decorated, there was no competition. Globally, unglazed ceramics survived only where glaze had not been developed. However, that is *not* to say they were or are primitive – experiments to replicate bonfire firings as used in West Africa have usually met with total failure in the UK. In fact, this technique represented a sophisticated use of local resources.

English slipware is one of the high points, not only of slip decoration but the whole history of pottery. The display of dishes by Thomas Toft in the City Museum and Art Gallery in Stoke-on-Trent is stunning. Bernard Leach's admiration for slipware affected not only the course of studio ceramics in the west, but through his lifelong friendship with Shoji Hamada and Soetsu Yanagi influenced Japanese potters too; medieval slipwares have been exhibited in Japan to great acclaim, and recently Clive Bowen exhibited and demonstrated there. With Hamada, Leach rediscovered slipware techniques at the pottery in St Ives in the 1920s – one story has it that after slicing through Cornish cream and jam on bread, they realised how a technique known as feathering had been achieved (see also p.19 under 'secondary applications' for more on feathering; see images on p.13 and p.19 for examples).

As a contrast to the relatively precise technique of English slip trailing, Korean and Japanese potters employed a much freer approach. The hakeme brushwork on bowls, slip-trailed calligraphy, and dribbled and splashed slip all have a loose feel to them, a Zen appreciation of the moment.

The main inspiration for the revival of interest in slipware in the 20th century has to

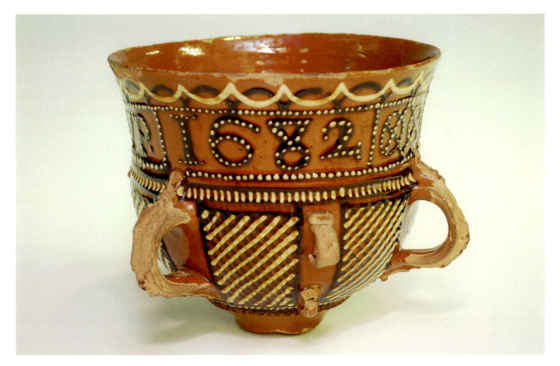

Posset cup, dated 1682, Staffordshire ware, (h. 14.5 cm/5¾ in.) PHOTOGRAPH BY JOHN MATHIESON, COURTESY OF NORTHAMPTON MUSEUMS AND ART GALLERY.

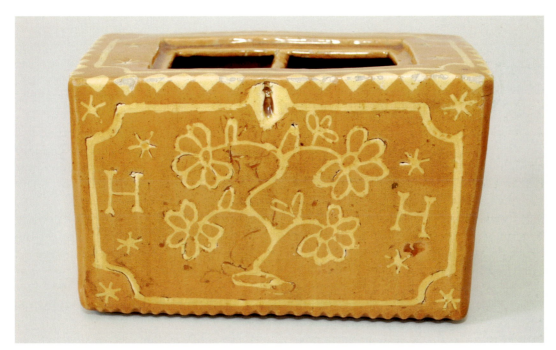

Tea caddy, inlaid slip decoration, Sussex c. 1850, (w. 18 cm/17 in.). PHOTOGRAPH BY JOHN MATHIESON, COURTESY OF COTSWOLDS LIVING PUBLICATIONS.

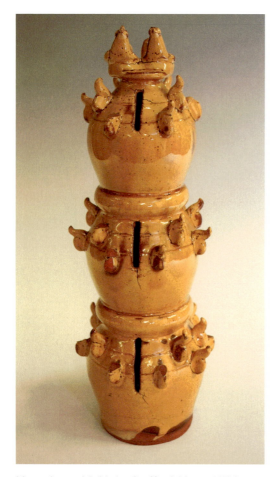

Moneybox with birds, Staffordshire c.1700
(h. 33 cm/13 in.). PHOTOGRAPH BY JOHN MATHIESON,
COURTESY NORTHAMPTON MUSEUMS AND ART GALLERY.

be Michael Cardew, Leach's first and most important pupil. After leaving St Ives he renovated the Winchcombe Pottery in Gloucestershire, where he made some of the most beautiful pots of the last century. (John Edgeler [see Bibliography] has written several books on and around this subject – of his extensively illustrated *Michael Cardew and the West Country Slipware Tradition* Clive Bowen said, 'John, you have made a book for potters'.) Although Cardew's later work was in stoneware, he always maintained that he was a slipware potter at heart, and many of the decorating techniques he used came

directly from his years at Winchcombe. I have a stoneware storage jar purchased *c*.1980 at his Wenford Bridge Pottery, which is in effect high-fired slipware, with a glaze remarkably similar to the galena glaze, used during the Winchcombe years. Ray Finch, Cardew's student, later took over Winchcombe Pottery, which now makes stoneware.

Peter Dick trained with Cardew in Nigeria, and then with Ray Finch at Winchcombe, before establishing his own workshop at Coxwold in North Yorkshire. There he made high-fired slipware (using oil and wood in a large kiln) and trained a number of potters. He has since switched to electric-fired slipware, and some stoneware. In my opinion Peter Dick is the most underrated and neglected of all British potters. His generosity of form, the warmth of his glazes (especially from the wood-firing), and the exceptional quality of his slip trailing and brushwork mark him as an outstanding artist.

Two influential books came out of the slipware revival (both can be found in the Bibliography). John Pollex wrote *Slipware* in 1979 (unfortunately, before the widespread use of colour plates). It reflected his then traditional way of working, using honey-coloured lead glazes; he now uses brightly coloured slips to create abstract patterns, a long way from his original approach.

Mary Wondrausch on Slipware was published in 1986 (2nd edition 2001). Mary is a character, and a regal presence at many shows in the UK. Through both her work and her writings she has brought an appreciation of slipware, and indeed of pottery as a whole, to a wide audience. Her book displays the depth of her knowledge, and the extent of her research into the history of slipware.

The use of slip in innovative ways, with or without a glaze, continues to develop internationally. Sometimes it is a simple

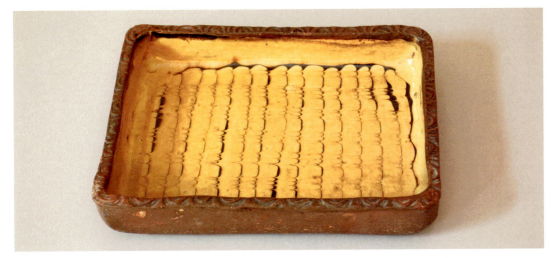

Press-moulded dish with feathered slip by Ray Finch, 1937, (19.5 x 14 cm/7¾ x 5½ in.). PHOTOGRAPH BY JOHN MATHIESON, COURTESY OF COTSWOLDS LIVING PUBLICATIONS.

brushstroke, as in Yo Thom's work, or it can be the principal surface treatment, as with Jenny Mendes's figures. Fritz Rossmann uses a solid band to punctuate his porcelain forms and contrast with the celadon glaze, while Ashraf Hanna uses coloured slips to highlight areas of his unglazed raku vessels. The almost abstract-expressionist decoration on Clive Bowen's magnificent domestic ware has evolved from his free methods of decorating. These all point to a living, creative process, which of course is essential to the well being of any art form.

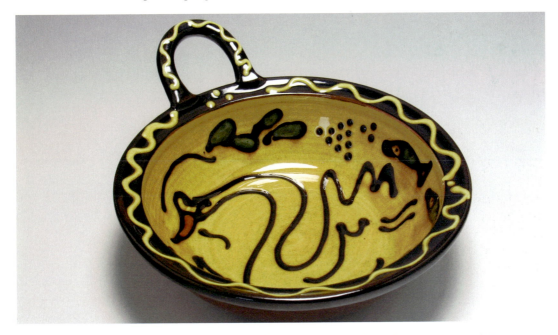

Swan Dish by Mary Wondrausch, (d. 20 cm/8 in.). Slip-trailed with lead sesquisilicate glaze. PHOTOGRAPH BY DAVID BINCH, OAKWOOD CERAMICS.

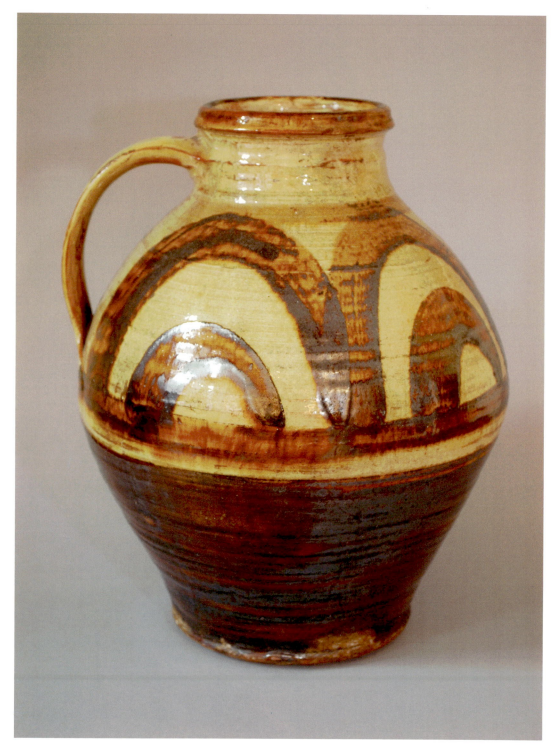

Michael Cardew jug, Winchcombe 1929, (h. 25 cm/10 in.), medieval form. COURTESY OF COTSWOLDS LIVING PUBLICATIONS. PHOTOGRAPH BY JOHN MATHIESON.

2 Application Techniques

Slips can be applied to clay in any way that works for you – there are no rules or prohibitions, and you may discover original techniques for yourself. One evening in the early years of my involvement with ceramics I was having fun spraying cleaner around the bath (before showers had been invented) and thought, 'This could work on a pot'. I tried it the next day using a slip trailer, and it did – 'splash lines' (as I call them) remain a feature of my work to this day. I have of course since discovered that Shoji Hamada, Clive Bowen, and many other potters use similar methods (Hamada used a chipped ladle that gave a thinner secondary line), but at the time this was my own original idea.

My advice is to try out techniques, and, except to understand a method, never copy. Instead, allow your own ideas to develop. Pottery is an art form, and your work should be individual, and evolve over the years.

Getting ready to decorate

Perhaps it is stating the obvious, but you need room to work, including clean surfaces and all the tools you need to hand. You should also have a bowl of clean water and a sponge for wiping excess slip from the pots and tools, as well as a bucket of water or sink in which to wash your hands.

Most people apply slip when their pots are leatherhard or softer; a few when the clay is bone dry (but this is unusual and can cause problems with adhesion). I would suggest that you start by applying slip to your work when it is on the slightly damp side of leatherhard; at this stage the clay is firm enough to handle, but moist enough to hold the slip without it drying and flaking off. With more experience you may decide to decorate on softer or harder clay. Niek Hoogland uses both techniques – he dips or pours the background slip when the clay is leatherhard, but does all further decorating when the pot is bone dry.

Primary applications

Dipping and **pouring** are the simplest ways to apply slips. Your slips should be of a creamy consistency – too thin and they may not show well on your finished pot; too thick and they could saturate and deform the pot whilst drying.

It can make life easier for both dipping and pouring if, when making, you have considered how you will hold your pot during this process – and how you will put it down afterwards. Many throwers leave a small ridge or groove at the base of the pot that gives them somewhere to grip; others only dip the top two-thirds so they can grasp the lower part of the pot. My bowls have a turned foot-ring that I can hold.

Some potters **brush** slip directly onto their work because it's how they prefer to work, but it's also an easier approach if your pot is too big to dip. Clive Bowen uses this technique frequently and is happy with the variations in thickness that it gives, while Richard Phethean deliberately exploits this method to create both texture and multiple layering in his work. The inexpensive soft Chinese brushes

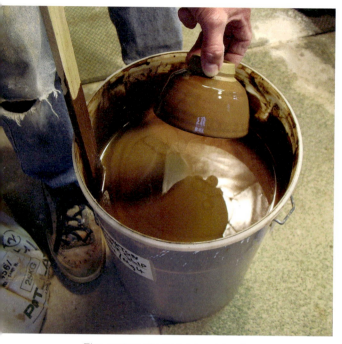

The author dipping a bowl in slip. PHOTOGRAPH BY JOHN MATHIESON.

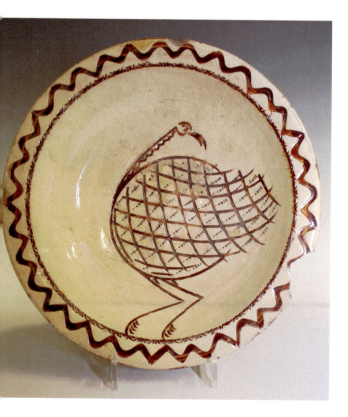

made from multiple fingers of bamboo hold a lot of liquid and can be very expressive. Some potters will even pour a little slip into the base of a thrown bowl and then use a brush to spread it up the sides – a coarse brush can give added texture here.

Adaptability and imagination often go hand in hand with creativity – I once saw film of Alan Caiger-Smith, whose onglaze brushwork is superb, making patterns using the hair from a spaniel's tail that had been sent to him from New Zealand as a challenge. Hamada made brushes using the hair from his Akita dogs.

Drawing through slip to reveal the contrasting clay body underneath is known as **sgraffito** (from the Italian *graffiare*, 'to scratch'), and can be done at all stages, from freshly dipped to dry. Soft fluid lines can be created using a modelling tool in the still-damp slip. I have used this technique extensively with a round-ended wooden tool to make 'punctuation marks' (the expression comes from Michael Cardew), which highlight the form. Sharper lines can be made with a broken hacksaw blade – in fact any tool can make its own mark, and you should feel free to experiment.

Combing through the still-wet slip can give beautiful patterns of swirling, wavy or straight lines. It is usually done with a notched rubber or wooden tool; a rubber kidney cut to shape is perfect, but make sure the teeth have sufficient space between them to form the pattern.

Etching through drier slip to create lettering, images and patterns is a technique often seen in North Devon slipware – very complex images can be created in this way.

HEALTH WARNING: scratching bone-dry slip will create hazardous dust, so always wear a dust mask.

Left: Bird dish, sgraffito through white slip onto red clay body, probably 19th century, (d. 33 cm/ 13 in.). PHOTOGRAPH BY JOHN MATHIESON, COURTESY OF NORTHAMPTON MUSEUMS AND ART GALLERY.

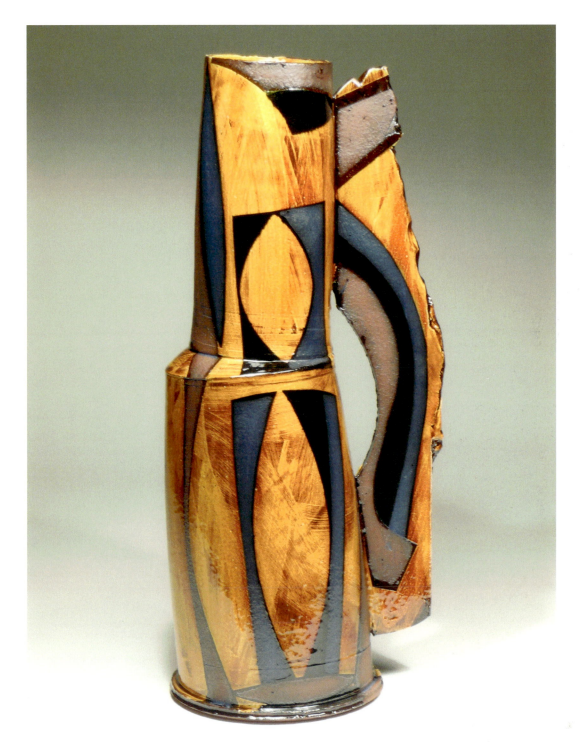

Richard Phethean's jug form, using paper resist with brushed slips, (h. 53 cm/21 in.). PHOTOGRAPH BY RICHARD PHETHEAN.

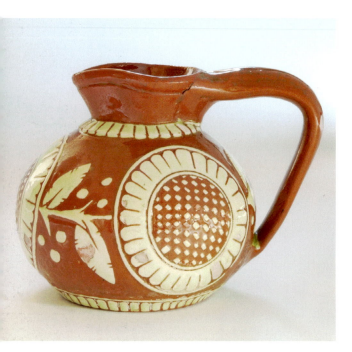

North Devon jug *c.*1880 with sgraffito decoration, (h. 8 cm/3 in.). COLLECTION OF LYNN AITKEN. PHOTOGRAPH BY JOHN MATHIESON.

Combed dish by John Mathieson, (d. 22 cm/ 55 in.). PHOTOGRAPH BY JOHN MATHIESON.

Hakeme, a Japanese word, refers to slip applied to a pot made from a contrasting clay, which is then patterned with a coarse brush made from, for example, dry grass from your garden or a nearby field.

Slip can be **sprayed** from a spray gun to give contrasting areas of colour and soft fade-outs. Jim Bassett uses one he purchased at a car spares superstore. You may need to sieve through a 120s mesh to avoid blocking the nozzle.

With **inlay**, impressed marks made in the clay body using stamps, or with a wooden tool, can be painted over and filled in with a contrasting slip, which is then scraped back to reveal the pattern. Motoko Watanawa (UK/ Japan) has used this technique extensively.

Terra sigillata is an ancient technique developed in the eastern Mediterranean during the first century BC, which is particularly associated with red Roman wares. It has a smooth, almost glaze-like surface – similar in fact to a slightly matt glaze – that allows fine detail to be seen. Terra sigillata slip is made by repeated levigation – it is stirred, sieved and allowed to settle before the top layer of slip is siphoned off and saved, the rest being discarded (to be used as ordinary slip or recycled as clay). Some potters do this only once, while others may repeat the process several times, resulting in an extremely fine slip, which is perhaps only 1 or 2% of the original weight.

Secondary applications

Obviously, the techniques outlined above are decoration in themselves. However, in this section I want to look at the way in which additional decoration is applied to those methods.

Slip for **trailing** (e.g., for lettering using a rubber slip trailer, and for lines and dots) needs to be thicker than for dipping; thick

cream is the usual analogy. It takes practice to do neat lettering with a slip trailer; I suggest you start with a thick slip, as runny slip will make the learning process more difficult. Experiment on newspaper at first, not on your precious work (the slip can be left to dry and then recycled). Later, when you have more confidence, try making your work looser by using a slip with a thinner consistency.

Slips can be effectively used as **paint** to create pictures on clay. Mary Wondrausch employs this approach very effectively in her work and paints images full of character. Just as with painting, you will find that you need to vary the thickness of the slip, from a thin wash to thick goo. Again, experiment on paper before committing to your pot. You could also try out ideas on quickly rolled slabs of clay cut into test tiles, which can be kept for future reference, once fired. They should be carefully labelled, either by marking the back whilst the tile is still leatherhard or with a permanent marker after firing, as inevitably you will forget which slip was which.

Slip on slip has traditionally been used to create linear patterns and lettering. One development of this is **feathering**, in which a needle (or feather or thin wire) is pulled at an angle through parallel lines of, for instance, white slip on a black background while the slip is still wet. Most local museums in the UK have examples of this technique on display. **Swirling** involves having two contrasting wet slips, usually in a dish, which is given a twist or a knock, resulting in a random pattern of slip decorating the bowl.

Slip can be printed onto the clay body or background slip using a **sponge** to produce a repeated pattern or textured background; different textures of sponge foam dipped in the slip and used to decorate will give different results. Sponge decoration can

Korean bowl with inlaid sgraffito and stamp under a thin glaze, reduction-fired stoneware, date unknown. PHOTOGRAPH BY JOHN MATHIESON/AUTHOR'S COLLECTION.

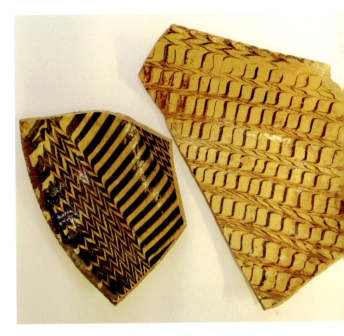

Feathering on shards (max. w. 25 cm/10 in.). COURTESY OF NORTHAMPTON MUSEUMS AND ART GALLERY. PHOTOGRAPH BY JOHN MATHIESON.

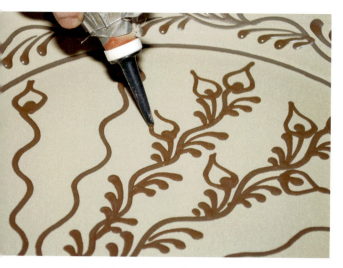

Paul Young slip trailing. PHOTOGRAPH BY JOHN MATHIESON.

Dish by Paul Young (d. 32 cm) with sponged background slip. PHOTOGRAPH BY JOHN MATHIESON.

range from printing to stippling (lightly dotted on), through everything in between.

Paper resist involves cutting out shapes from paper, dampening and then sticking them to the clay or slip surface, and then applying slip, which can enable the creation of lettering and repeat or abstract patterns. Lifting the paper before the slip dries (using a pin) will give softer edges to the slip.

With **wax resist**, either hot or cold wax is brushed on the pot's surface; being waterproof these marks prevent the slip (and glaze) sticking. You will find small dots of either slip or glaze held by surface tension in the waxed areas, but I think these random 'imperfections' add to the effect. Wax emulsion – used straight from the bottle – is so convenient, and so much kinder to my brushes, that I have never felt the need to use hot wax. To be fully effective it needs time to dry out properly – an emulsion contains water. That strange smell coming from the kiln during the firing is the wax burning off.

Chatter is a technique in which the end of a curved, springy metal tool is held against the touch-dry slip while the pot is turned on the wheel. The end bounces and takes small repeated bites of clay, revealing the contrasting body underneath and creating a pattern. It is associated with Japan, but I have seen photographs of traditional Swedish pottery from the 1870s with the same markings, in an old Swedish craft magazine.

A problem

On old slipware (made from red clay) you sometimes see areas where the slip-glaze layer has lifted away from the clay body, especially on rims and on the edges of handles. This is caused by poor adhesion of the slip layer, which (especially if it is white- or buff-firing) is likely to be a stoneware clay with a higher maturation temperature than the earthenware body to which it has been applied. It never occurs at stoneware temperatures because the different layers – body, slip, glaze – fuse together much more than at the lower temperatures used for slipware. With red clay slips, which are usually earthenware and very similar in composition to the red body, the problem is highly unlikely to occur.

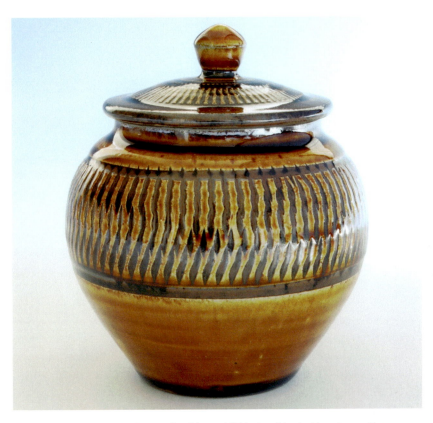

Storage jar from Onda, Japan (h. 11 cm/4½ in.) with chatter decoration through white slip. PHOTOGRAPH BY JOHN MATHIESON/AUTHOR'S COLLECTION.

Some potters working in the 1050–1150°C (1190–2100°F) range encounter this problem, usually irregularly, and others are never affected by it, even when using similar materials. Should this happen to you there are several possible solutions:

1) Try slipping the pot sooner than you have been doing, when it is damper.
2) Add 10% flint to the slip recipe.
3) Add 5–10 % frit to the slip recipe, using the same frit as in your glaze.
4) After much experimentation, Roger Cockram discovered that adding 10% nepheline syenite to his slip improved adhesion.
5) In their invaluable *The Potter's Dictionary of Materials and Techniques* (see Bibliography), Frank and Janet Hamer suggest adding up to 20% borax frit to the slip, which has the further advantage of encouraging the bleeding of colour from slips into the glaze.
6) Some potters biscuit-fire to a higher temperature than they glaze, for example to 1140°C (2084°F) followed by a glaze-firing to 1065°C (1950°F).
7) Use an earthenware clay as the slip.
8) Clive Bowen routinely wipes the slip from the rim of his pots with a finger, which resolves the issue by removing the problem.
9) In the UK a number of potters who use Hyplas 71 ball clay to make a near-white slip report few or no problems.

Note: Please see p.137 for health and safety information on lead glazes.

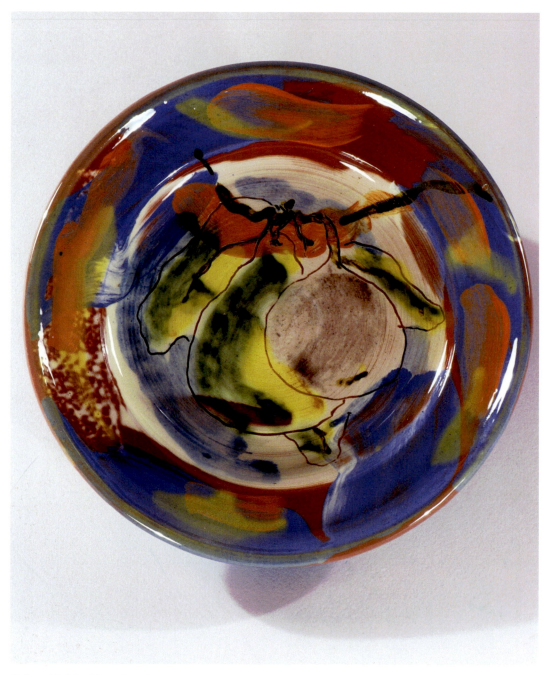

Quince Dish by Mary Wondrausch, using painted slips.

3 Mixing Slips

For one bucket of slip you will need:

- Powdered or dry clay, approx. 5–7 kg/ 11–15 lb
- Oxides/body stains (if required)
- Sieve, 80s or 100s mesh
- 2 wooden struts to support the sieve
- Stirring stick
- Jug
- Coarse brush
- Rubber kidney
- Face mask
- Two buckets

It is much easier to make a slip if the clay is in powder form or has been broken down into small pieces. You can hammer larger clumps of clay in a bag to break it up, or use a pestle and mortar to grind it down. Lumps of hard, dry clay exfoliate when placed in water and will mix easily if left overnight; by contrast, a bag of damp to leatherhard clay can take months to become mixable. I have used a cheese slicer to shave thin slivers of leatherhard clay, which then dry rapidly and are easier to water down and disintegrate.

To mix my slip, I use brewing buckets or recycled honey buckets from a local health-food store. These hold a large volume of liquid, which means I have sufficient depth to immerse tall pots, and I don't have to mix so often. For one bucket of slip, fill the bucket halfway with water, then weigh out and add the materials, as given above. (Obviously, for less slip, you need to proportionately adjust the amount of water and quantities.)

Two important points:

1) Always add ingredients to water, never the other way around, as the latter creates far more dust.
2) Whenever mixing slip or glaze, make a note on paper of each amount of material as it goes into the bucket – a phone call, a visit from your cat or daydreaming can all make you forget what you've added.

Before sieving I mix all the materials in the bucket with an electric paint mixer, a tough piece of kit that will even mix concrete. *Always*

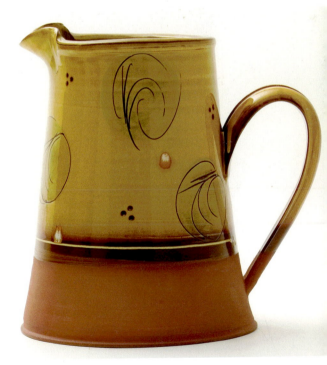

Jug by Jennifer Hall, see p. 70, (h. 28 cm/11 in.).
PHOTOGRAPH BY JOHN TIBBS, ASCARI PHOTOGRAPHIC.

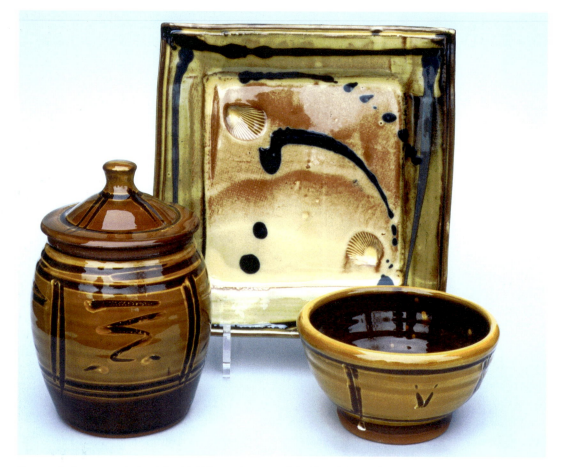

Group of slipware pots by John Mathieson (square dish 22 x 22 cm/8¾ x 8¾ in.). PHOTOGRAPH BY JOHN MATHIESON.

use a powerbreaker! If you don't have a paint mixer, however, you can simply stir it with a wooden stick for longer, or try a handheld manual or electric kitchen whisk – although once used in the studio it can never be returned to the kitchen!

It is much easier to sieve the slip if you leave everything to soak overnight. I pour the mix into the sieve, which is supported over another bucket by two sticks, and using a nylon pan-scrubbing brush, force the slip through the mesh. Wipe out the remnants from the first bucket into the sieve with the rubber kidney, and repeat the sieving process. (Rob Burgess uses a rotary sieve – manually turned brushes push the slip or glaze through the mesh; he describes it as 'a wonderful piece of kit').

When all this has been done (and whenever you use slip), wipe any splashes above the waterline down into the slip with a rubber kidney; this helps prevent lumps forming.

Slip thickness

I try for quite a thick mix initially as it is always easier to add water than to remove it. If you do need to decant water from the slip, leave the bucket on a bench or chair overnight to allow the slip to settle, and siphon off the excess the following day (the bucket needs to be high up, so that gravity will help the siphoning process).

The thickness of slip for dipping and for trailing will be different. As a rough guide, dip your finger in the slip, and if you can just see the creases of your skin through the slip, it is correct for dipping. For trailing it should be like thick gravy.

Your slip will need to be stirred thoroughly before you use it. But a word of warning – if you overuse the electric mixer, you can loosen the bond between the particles in the slip, resulting in a watery mix that takes time to thicken again. A wide stirring stick or paddle is slower, but just as effective.

Labelling

Many slip and glaze materials look similar in the bucket and the bag, so please make sure you label everything properly. I always write the complete recipe on the bucket label using a permanent marker pen, and cover all labels with plastic laminate (book covering material) – it is waterproof, transparent, and sticky, with peel-off paper backing. I also mark all packets and bags of material as they are delivered, again with a permanent marker – labels can fall off, leaving you with an unknown whitish powder.

Testing

Occasionally if I want to test a clay, or mix an experimental quantity of slip or glaze, I use a small 75 mm (3 in.) 100s mesh sieve. It's quick and efficient, even though a small-scale test may only give an indication of what you will achieve with a full mix. A good quantity for testing purposes is 100g of slip or glaze.

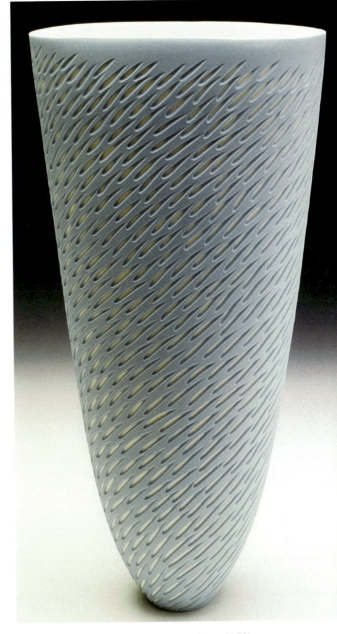

Shoal Vase by Sasha Wardell, (h. 40 cm/15¾ in.). Slipcast bone china with incisions through multiple layers. PHOTOGRAPH BY SEBASTIAN MYLIUS.

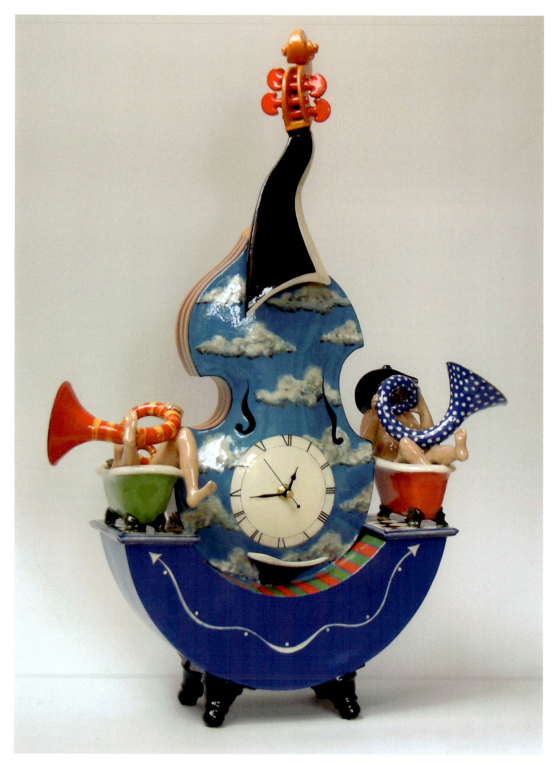

An' all That Jazz, clock by Ross Emerson (h. 56 cm/22½ in.). PHOTOGRAPH BY ROSS EMERSON.

4 Colour in Slips

Many potters, especially those making slipware, have only two or three slips in their repertoire. In contrast, Jenny Mendes has a range of around 175! How many different colours you use is down to you and your artistic intentions.

Most potters base their slips, however complex, on one or two known and reliable clays – a red clay for a black slip, and a white or off-white clay for all other colours. In the UK this light-firing clay is usually a ball clay – the name comes from the method of digging 25 kg (55 lb) lumps, which were known as balls, from the open clay pits. Ball clays tend to be very fine and plastic. Hyplas 71, TWVD and HVAR are popular ball clays widely used for slip decoration in the UK.

Colour in slips is achieved either by using different clays (either singly or as blends of two or more different clays), by adding oxides and carbonates to the slip (as we do to give colour in glazes), and by using body stains. As a guide:

Basic slips
- White or buff slip will give white or off-white
- Red clay slip will give reds
- Blends of white/buff and red clay slips will give a range of tans.

Oxides and carbonates
- Cobalt (oxide or carbonate) (0.5–4%) will give blues
- Copper (oxide or carbonate) (1–5%) will give greens
- Cobalt and copper together will give turquoise
- Iron oxide (1–10%) will give browns
- Manganese dioxide (1–10%) will give browns
- Iron and manganese together are used to give black
- Chromium oxide (0.5–4%) will give greens.

Body and underglaze stains
Commercially available body and underglaze stains can be added to the basic white slip to give a wide variety of different colours, and if you want really bright colours this is what you should use. Reds, yellows and oranges in particular can be expensive – over £50 (US$75) for 500 g! The proportions required tend to be higher than with the oxides listed in the recipes above – 10–15% is normal.

As always, experimenting with different percentages, or blends of made-up slip, can give you interesting and individual results. For example, you could try using different proportions of green and blue slip to find a turquoise.

Basic slip recipes

With the exception of the black slip, which is a standard recipe and the one I use, the oxide additions are given as a guide, a starting point for experimentation. However, they will all work.

Black slip

Any red clay	100
Iron oxide	4
Manganese dioxide	4

Note: Some potters add 1 or 2% cobalt oxide or carbonate to this recipe.

Red slip

Any red clay	100

White/buff slip

Ball clay (or any light-coloured clay)	100

Note: Some potters use white earthenware clay.

Blue slip

Ball clay	100
Cobalt carbonate	2–4

Cobalt carbonate makes the slip look slightly blue; cobalt oxide is black, coarser, more expensive, and gives a stronger colour.

Green slip

Ball clay	100
Copper carbonate	4–8

Copper carbonate makes the slip look green; copper oxide is black, coarser, more expensive, and gives a stronger colour.

The colours of all slips will be modified by whichever glaze you use over them – if you use glaze. The differences can be amazing – the black slip above gives a dense black under a lead bisilicate glaze at 1110°C (2030°F), but under my talc glaze at 1280°C (2336°F) it produces a range of colours, from variegated brown to a soft speckled green.

Note: When used under a lead glaze, copper compounds increase lead release and so should only be used on surfaces that will not come into contact with food.

Experimenting with local materials

While you can obtain everything you need from a pottery supply company, it can make for a more interesting – and individual – approach to find your own clays for decoration. Clive Bowen and Doug Fitch make slips from clays found by streams running near their respective workshops; Jim Malone and Mike Dodd both make extensive use of the geology in their local area.

Unlike clay for making your pots, you don't need vast quantities to prepare a decorating slip – a piece the size of a tennis ball will be sufficient for basic testing. After mixing with water (dry clay slakes down much more rapidly than wet), your sample will need passing through an 80s mesh sieve. I have a small 75 mm (3 in.) sieve which has proved remarkably useful over the years for just this sort of thing. Test the slip both as a thick mixture and a thin mixture, and be aware that the colour it becomes may be very different from that of the raw material. Remember to label your tests!

Artists' Approaches

It isn't possible to write about potters strictly according to the methods they use – very few confine themselves to only one slip technique in their work. In fact, most employ several, and are happy to maintain a flexible approach in order to realise new ideas as the need arises.

I have used a flexible approach myself in grouping potters for this book. The first chapter covers artists who do not use glaze, and examines a wide variety of approaches using many different clays and a range of firing temperatures. The second looks at the use of slips in raku. Inevitably, in a book on this subject, slipware potters working at earthenware temperatures form the bulk of practitioners – evolving from the historical tradition, this is where the greatest use of decoration with slips is to be found. In contrast, the use of slips on stoneware and porcelain, and in saltglaze, tends to have a more subtle and modifying effect on the glaze, and this is examined in the last two sections.

It is important to remember that most techniques can be used (or adapted for use) at all temperatures and for all types of firing. Your results will be different, but that's how it should be. Experimenting and exploring, and absorbing ideas and influences will enable you to create your own individual work.

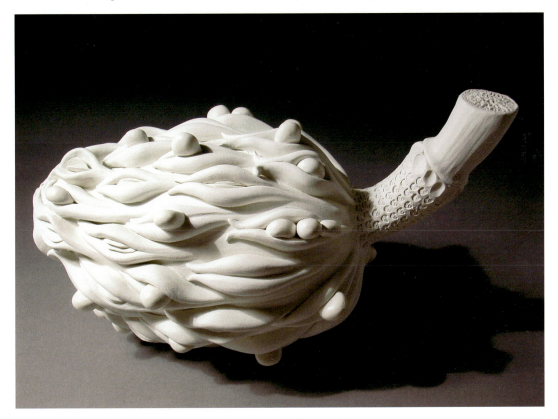

Magnolia Pod by Alice Ballard, (36 x 23 x 25 cm/14¼ x 9 x 10 in.). PHOTOGRAPH BY CHRISTOPHER CLAMP.

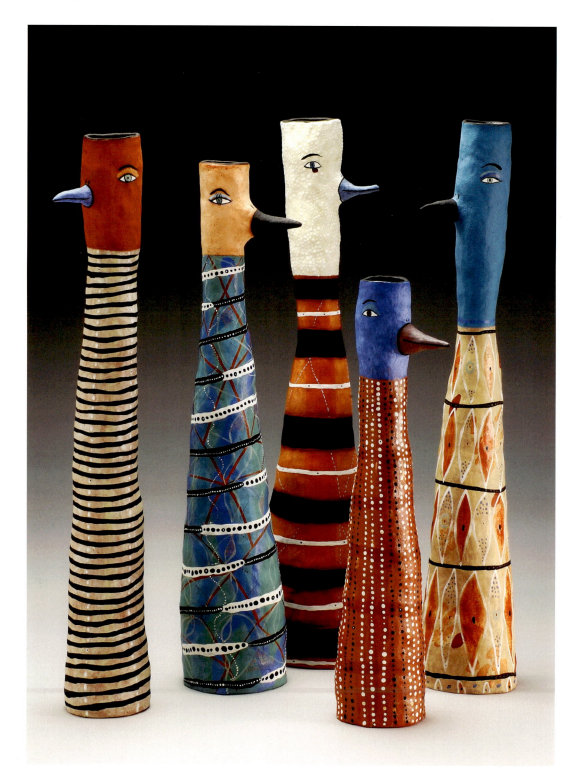

Collection of Birds by Jenny Mendes (h.38 cm/15 in.). PHOTOGRAPH BY JERRY ANTHONY.

5 Using Slips Without a Glaze

Historically, pots from all parts of the world have been made without using a glaze, either from choice, or because the technology was not available. For the potters in this section, which presents the most varied selection of work in the book, the decision not to use glaze was made for artistic reasons.

Approaches range from Sasha Wardell's translucent slipcast forms to figurative pieces by John Maltby and Jenny Mendes, David Cooke's animals and birds, Alice Ballard's terra-sigillata forms, Lynda Harris's painterly decoration, and Rob Burgess's work with special-needs clients. They cover the complete range of firing temperatures and use a wide variety of clays, from coarse craft crank to fine bone china.

Looking at Sculpture by John Maltby. Courtesy of Oakwood Ceramics. PHOTOGRAPH BY DAVID BINCH.

Jenny Mendes (USA)

Jenny Mendes has been a full-time artist since the mid-1990s. Originally from Ohio, she took a fine arts degree at Washington University, St Louis, Missouri, and it was while there that, following a suggestion from a friend, she first experimented with drawing on clay tiles. She later studied at the Penland School of Crafts in North Carolina. Since then she has exhibited widely and her work has appeared in numerous publications.

Jenny works with terra-sigillata slips without a glaze, and makes both figurative pieces and painted tiles. I find her work beautiful, intriguing, highly accomplished and at times disturbing; it can be challenging, and not always easy viewing.

Working methods

Jenny's work is made from terracotta clay, and is entirely handbuilt using basic techniques and minimal tools. All pieces are one of a kind, though Jenny will occasionally work in series, extending an idea in different ways. 'An intimate scale, evident in all of my work, speaks directly to the viewer's capacity to personally interact with a piece that fits easily within their grasp.'

Jenny makes her coloured slips from Kentucky ball clay. She mixes one part clay to three parts water, which she allows to settle for 24 hours, and then siphons out the layer of slip between the water at the top and the heavy clay at the bottom. She adds Mason stains to this terra sigillata for colour, and then likes to run it in a ball mill for a smoother and finer mix. In all, Jenny has around 175

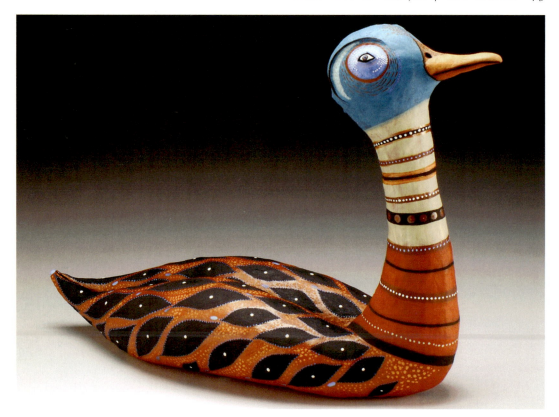

Loon by Jenny Mendes (h.30 cm/12 in.). PHOTOGRAPH BY JERRY ANTHONY.

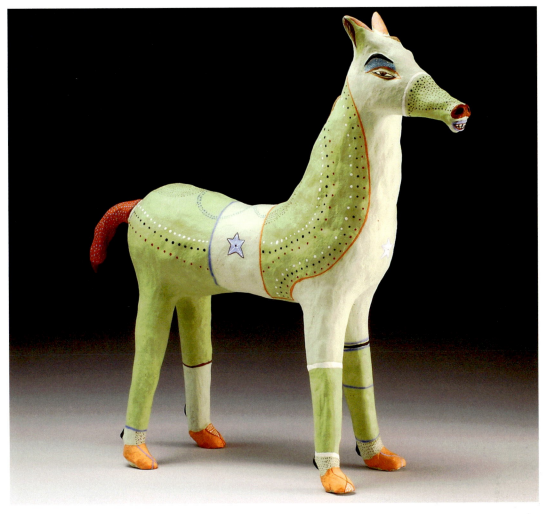

Green Horse by Jenny Mendes (h. 30 cm/12 in.). PHOTOGRAPH BY JERRY ANTHONY.

different colours. The slips are painted on her works in multiple layers. Tiles are placed between sheets of gypsum and allowed to dry completely before painting begins.

Technical information

Clay Commercially available low-fire terracotta clay.

Slips Terra sigillata made from Kentucky ball clay with added Mason stains.

Firing Work is fired to cone 03 (1090°C/ 1994°F) in an electric kiln, often several times, with a five-minute soak at top temperature.

Lynda Harris (NEW ZEALAND)

Lynda Harris makes a variety of ceramics, specialising in one-off pieces with slip-painted imagery. After leaving school Lynda learnt to use clay with some potting friends and by attending weekend courses; she later graduated from Monash University, Australia, a ceramic course she completed by distance learning. She has been active at all levels of ceramics in New Zealand, and was vice-president of the NZ Society of Potters for two years. Her work is held in many public and private collections.

For many years Lynda worked in raku, but for health reasons changed to firing at earthenware temperatures in an electric kiln. She is particularly interested in decorating; painting onto a curved surface and working around the form are challenges she enjoys. New Zealand's scenery and nature, especially birds, are the inspiration for the images that wrap around her bowls. Lynda's work is distinctive partly because of the imagery she employs, which to me speaks strongly of New

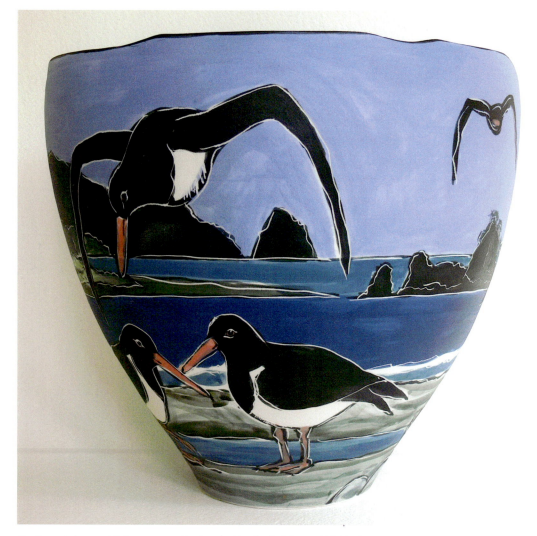

Oystercatchers at Whangapoua by Lynda Harris (h.32 cm/12½ in.). PHOTOGRAPH BY LYNDA HARRIS.

Zealand, and because of the strong unglazed colours she uses.

Working methods

Lynda's work is both thrown and handbuilt. The forms are decorated with slip on the dry clay, and any sgraffito is done at this stage. Slips are made from the body clay with 10% borax frit, and body stains are added in varying amounts before the slip is sieved through 120s mesh. Colours are mixed in the same way 'as one would mix watercolour paints on a white palette to obtain graduations of colour, or with uncoloured slip to weaken the colour'. The slips are dull when painted onto the pot, with experience enabling Lynda to anticipate the final result.

A slip and glaze suspender and hardener, 'Rados', is added to the slips; despite being painted onto the dry pot there are no problems with peeling or different rates of shrinkage.

After biscuit-firing, only the interiors are glazed. The pots are fired to high earthenware temperature, which intensifies the colour and gives a matt surface to the slips.

Technical information

Clay Abbots White clay (from New Zealand)

Slips The clay body with the addition of 10% standard borax frit; body stains are added for the different colours.

Glaze Abbots Clear KMG 271P, coloured with glaze stains.

Firing Work is biscuit-fired to 970°C (1778°F) and glaze-fired to 1165°C (2129°F) in an electric kiln.

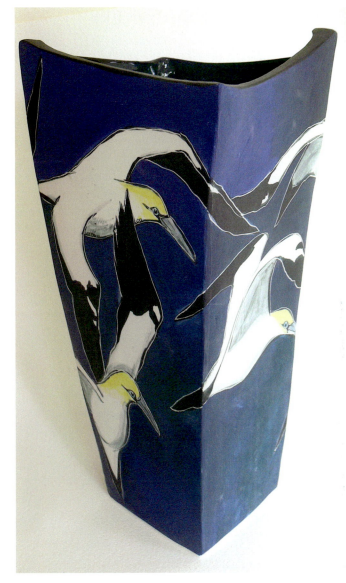

Gannets in Flight by Lynda Harris (h. 42 cm/ 16½ in.). PHOTOGRAPH BY LYNDA HARRIS.

John Maltby (UK)

John Maltby has had a long and distinguished career as an artist, with work in many international collections, including the Victoria and Albert Museum in London. He originally studied to be a sculptor at Leicester School of Art, but a chance reading of Bernard Leach's *A Potter's Book* led to John working with Leach's son David at Lowerdown Pottery from 1962 to 1964. He then established his own studio in Devon where he developed work with a highly individual decorative style.

His art has continuously evolved over the years and is not confined to ceramics – it includes oil painting on wood, and mixed media on paper, often with fishing boats as raised images.

Following an illness in 1996 John was unable undertake anything strenuous, and so made small objects on his kitchen table. He enjoyed both the challenges and the potential of this new direction, and has developed these sculptures ever since. They feature people, angels, heads, birds, animals and demons, and often have a strong spiritual element to them.

Three Figures by John Maltby. Courtesy of Oakwood Ceramics. PHOTOGRAPH BY DAVID BINCH.

Working methods

All pieces are handbuilt employing a variety of techniques, especially using slabs and modelling, with added incised lines. Slips are applied by brushing *after* biscuit-firing to 990°C (1814°F), as this makes handling easier; they can, however, be painted onto dry unfired clay if required. John emphasises the importance of the suspender (a cellulose binder) in the slip recipes. He occasionally uses wax resist when painting slip over slip. He tends to use whatever will work at the time, depending on the piece.

Technical information

Clay Craft Crank

Slips (painted on biscuit ware)

White slip

HVAR ball clay	60
Fine molochite	40
Zirconium silicate	10

* Plus cellulose suspender

Black slip

Yellow ochre	9
Manganese dioxide	14

*Plus cellulose suspender

Red-brown slip White slip plus 10% synthetic iron oxide

Note: Coloured slips can be made by adding commercial clay stains (10% for medium intensity) or colouring oxides to the white slip.

Firing John has used many different types of kilns, from oil-fired stoneware and salt glaze to enamelling. He fires his current work in an electric kiln, slowly at first for biscuit (990°C/1814°F), and 'as fast as the kiln will go' for the second firing, which is to 1200°C (2192°F).

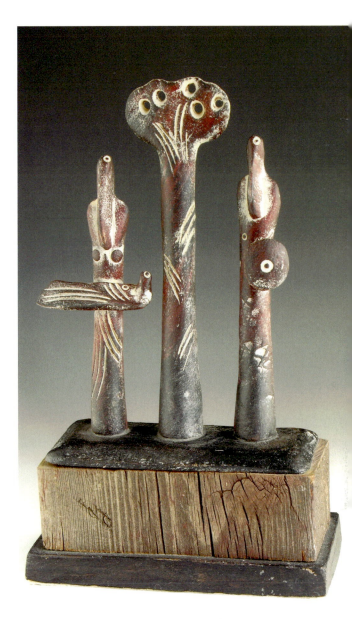

Family Group with Tree by John Maltby. Courtesy of Oakwood Ceramics. PHOTOGRAPH BY DAVID BINCH.

David Cooke (UK)

David Cooke has been a wildlife artist since he graduated with a degree in 3-D design. Though he occasionally uses other materials, including wood, wire and bronze, most of his work is in clay.

David has made a wide range of different animals, but has tended to specialise in birds and reptiles. His work ranges in size from small lizards to a one-metre snail and a massive Galapagos tortoise, and goes beyond being technically superb to capture and interpret the spirit of the animal.

Now based at the Sculpture Lounge Studios at Holmfirth, Yorkshire, with several other artists, David exhibits widely and runs courses at the workshop.

Working methods

David handbuilds using slabs of clay, and also press-moulds and slipcasts, for which he makes his own plaster moulds. He uses slips in three main ways – for casting, for mixing with hessian, and for printing through fabric.

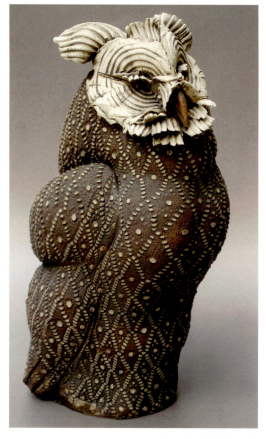

Above: Regal Owl by David Cooke, slip printed through fabric, (h. 55 cm/21¾ in.). PHOTOGRAPH BY DAVID COOKE.

Right: Slipcast owl by David Cooke, (h. 45 cm/17¾ in.). PHOTOGRAPH BY DAVID COOKE.

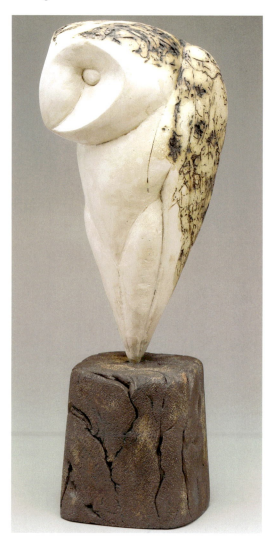

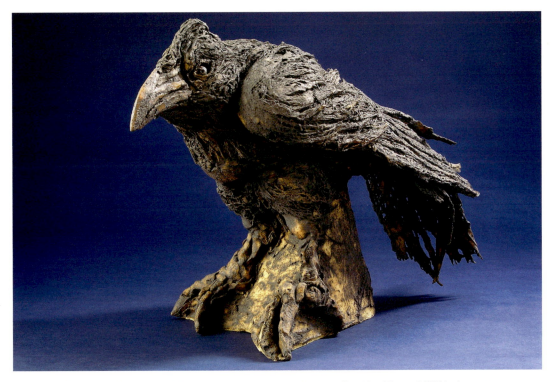

Raven by David Cooke, shaped from hessian scrim soaked in slip, (h. 45 cm/17¾ in.). PHOTOGRAPH BY DAVID COOKE.

Slipcasting is used for the more stylised pieces such as his barn owls. These employ a combination of two colours – first the inside of the mould is lined with hessian soaked in tan slip, then, after the two halves of the mould have been strapped together, a white slip is poured in. The hessian burns away during the firing, leaving a texture with a 'gnarly fur-like quality', which can be sanded down to give a 'cork-like effect'.

Hessian scrim, which has been soaked in slip, is also used by David to make creatures freehand. The scrim burns off during the firing, leaving holes that are later filled with glaze.

Evolving initially from experiments to create scales and feathers. David now prints through patterned fabric, usually using white slip onto contrasting clay. After the fabric has been peeled off, the sheet of clay is bent to the desired shape, distorting the pattern in the process.

Technical information

Clay Earthstone Crank ES50
Earthstone Handbuilding Material ES40
Earthstone Terracotta Crank ES65

These clays are available from Scarva Pottery Supplies and Valentine Clays.

Slips Scraps from all the above clays are turned into casting slips by soaking and then adding Dispex.

Glaze David usually glazes by brushing a combination of metal oxides into the detailed areas of his work, and occasionally adds a satin ash glaze, and commercial stains for colour.

Firing Work is biscuit-fired to 1000°C (1832°F) and glaze-fired to 1240°C (2264°F) in an electric kiln.

Alice Ballard (USA)

Alice Ballard makes individual pieces in low-fired white and red earthenware using a variety of handbuilding techniques; her work is decorated using terra sigillata.

Alice lives and works (with Roger Dalrymple *q.v.*) in South Carolina, where she was born. However, as a child she travelled extensively within the United States, and also spent three years in Paris. She took a Master's degree in painting at the University of Michigan and then returned to South Carolina to become the first Curator of Education at Gibbes Art Gallery in Charleston. She is now both a practising artist and a part-time teacher.

In her studies Alice was interested in painting and sculpture; she had no ceramics classes while taking her degree. Her interest in clay began when she saw Wayne Higby's graduate show at the University of Michigan. The combination of abstract expressionist influences and the immediacy of raku firing were a complete contrast to the mostly functional ceramics she had seen up to then.

Today her main inspiration is the very close examination of the minutiae found in nature – gardens (especially Zen gardens) and gardening are primary interests.

Working methods

Alice uses a variety of handbuilding techniques – slab-building, coiling, pinching, and dowel-forming (a wooden rolling pin inside a cylinder of clay which is then rolled to a larger size), plus the occasional use of extruded tubes. Bags of vermiculite, rocks, and basic press moulds are used as formers. Her favourite tools include rubber ribs, steel scrapers, fine trimming tools and paddles (some straight from her kitchen), and anything that will create the desired texture. She has a collection of brushes, mostly hake and bamboo, many bought during a trip to China.

Terra-sigillata slip is brushed or airbrushed onto the totally dry surface of the work; sometimes the raw clay surface is left exposed, or oxides, underglaze colours and engobes may be added. An HVLP (high velocity/low pressure) spray is used for airbrushing as it gives a fine finish with little overspray. 'Terra sig is a bit like adding a skin to my clay forms – it reveals the beauty of the clay as it enhances it, and keeps its warm and sensual qualities however I choose to use it.' Both matt and satin surfaces can be achieved – a soft hake brush and polishing with a plastic bag gives the highest gloss, while airbrushing gives a more eggshell-like surface.

Technical information

Clay From Highwater Clays

Slip **Terra sigillata slip**

EPK ball clay 1000 g (2.2 lb)
OM4 ball clay or Tennessee
ball clay 500 g (1.1 lb)

These clays are mixed with 14 cups of water and 1 teaspoon of sodium silicate. The mixture is allowed to sit for 48 hours, after which the top layer of terra sigillata is taken off using a soup ladle. For colours, add 1–3 tablespoons of Mason stains or oxides. This is applied when the greenware is completely dry.

Firing Work is fired to cone 04 (1065°C/1950°F) in a top-loading electric kiln.

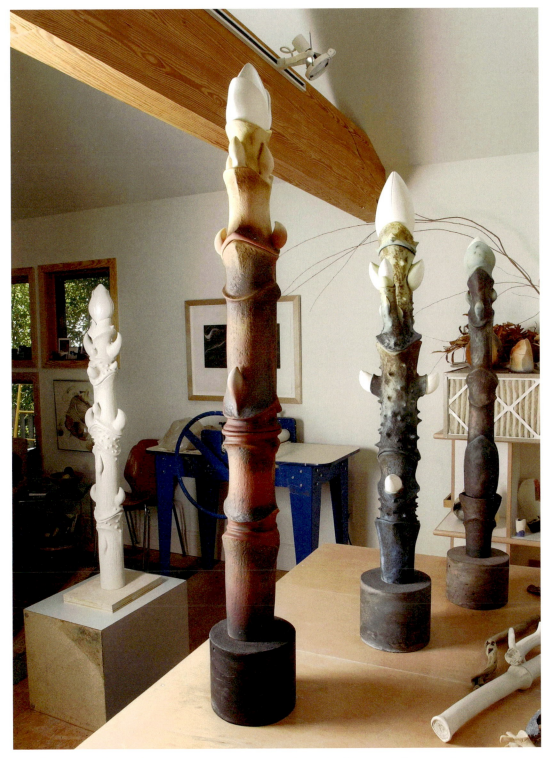

Tree Totems by Alice Ballard, work in progress in her studio (h. 153 cm/160 in.) PHOTOGRAPH BY
KEN OSBURN.

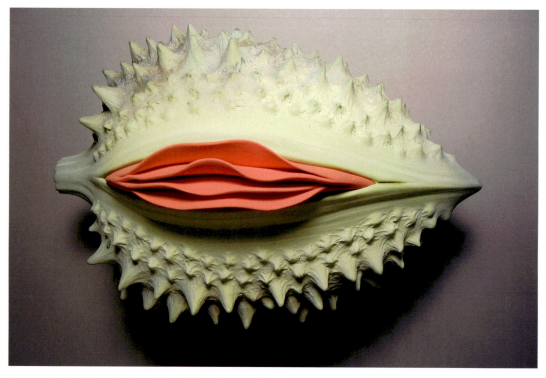

Poppy Pod by Alice Ballard (30 x 23 x 15 cm/12 x 9 x 6 in.). PHOTOGRAPH BY CHRISTOPHER CLAMP.

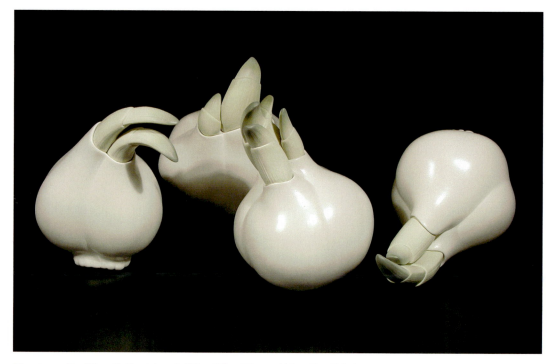

Narcissus by Alice Ballard (each 30 x 20 x 20 cm/12 x 8 x 8 in.) PHOTOGRAPH BY CHRISTOPHER CLAMP.

Roger Dalrymple (USA)

Roger makes individual handbuilt pieces in earthenware and stoneware.

Although Roger has been working with clay for a relatively short time, he brings to the medium an artistic sensibility gathered from a lifetime of both professional and personal interest. He ran his own architectural practice in Alaska, has a lifelong interest in the arts of native peoples, and has been inspired by both the design philosophy and craftsmanship he has encountered. In some Native American cultures a *kiva* is a spiritual or sacred place that is partially underground and entered from the roof by a ladder, and this concept is used in much of his work. He is married to Alice Ballard (*q.v.*), with whom he completed six large public arts projects in Alaska. They now live in South Carolina.

Working methods

Roger mainly slab-builds using low-fire earthenware and stoneware clays. All slabs are hand-rolled to the required thickness and are shaped over bags of vermiculite. Tools, including scrapers, knives and wooden paddles, are borrowed from his wife's studio as needed.

A mixture of red or white slip with flux and Mason stains is used to achieve the desired colour. This is allowed to settle for a few days and then sprayed through a commercial HVLP system (a high velocity/low pressure spray system). Roger usually

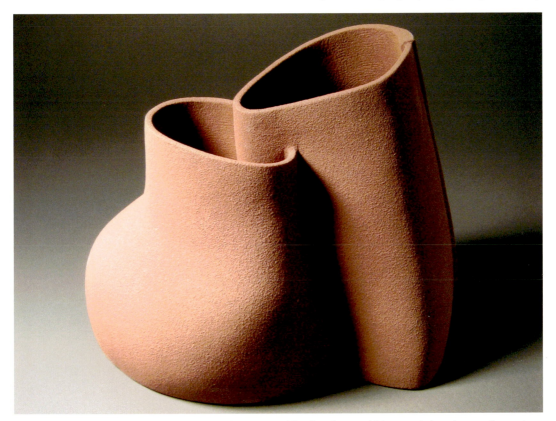

Kiva vessel by Roger Dalrymple, red earthenware with slip, flux and Mason stains, (max. dimension 51 cm/20 in.). PHOTOGRAPH BY ALICE BALLARD.

Kiva Vessel by Roger Dalrymple, red earthenware with slip, flux and Mason stains, max. dimension 90 cm/35½ in. PHOTOGRAPH BY ALICE BALLARD.

sprays two or three coats until he has achieved the texture and colour he wants. To flux the slips (to reduce their melting point, increase adhesion and give a desired texture) Roger and Alice add both gertsley borate and a small amount of commercial transparent glaze to the mix.

Technical information

Clay Roger uses Stan's Red, Brownstone, and Lyman Red from Highwater Clays.

Firing Work is fired to cone 4 (1065°C/1950°F) in a top-loading electric kiln.

Jude Jelfs (UK)

Jude originally studied fine art, becoming a potter after marrying John Jelfs. While she was a student the figure had formed the basis of her work, and in recent years she has been making figurative work in clay and occasionally bronze, as well as drawing and painting. Her work includes flat (almost two-dimensional) pieces in earthenware and porcelain that are built from slabs, and three-dimensional figures made in stoneware.

Note: For more information about Jude and John Jelfs please refer to their joint section, p.128.

Working methods

All work starts with life drawing. For the slab-built earthenware the drawings are adapted to make the final profile from which paper patterns are developed. Using these templates shapes are cut from flat sheets of clay, and then assembled. These are left until they are leatherhard, and then worked on with Surform blades and a steel kidney. They are painted with layers of slip, each layer being burnished to give a hard surface.

For her three-dimensional pieces (again, life drawing is always the beginning) a rough skeleton is made out of T-material and/or flax clay, bubblewrap, wooden barbeque skewers – anything either fireable or combustible. While this is drying to leatherhard, Jude makes the base, which is either slab-built or thrown and altered – she likes oval bases. The skeleton is fixed to this base using clay slurry and barbecue skewers, with metal rods providing external support; these are moved regularly while the work dries to allow for shrinkage. The base is packed with polystyrene or paper to give support. Porcelain slip is applied by brushing or dipping. Finally, the pieces are fired in John's soda kiln to stoneware temperature.

Black Odalisque by Jude Jelfs (h. 21 cm/8¼ in.).
PHOTOGRAPH BY JUDE JELFS.

Technical information for earthenware figures

Clay	Spencroft Special White Earthenware	
Slip	HV ball clay	50
	China clay	50
	Soft borax frit	35
	Black stain	20
Firing	Work is biscuit-fired to 1000°C (1832°F) and glaze-fired to 1120°C (2048°F) in an electric kiln.	

45

Rob Burgess
(WORKBRIDGE CERAMICS, UK)

Rob organises and runs the ceramics department at Workbridge, in Northampton, UK. Workbridge, as its name suggests, provides supported working experiences and skills training for people who have learning difficulties, mental-health needs and/or head injuries.

Rob began working in the field of mental health and learning difficulties day care after studying linguistics at university; his involvement in ceramics happened as a result of this. He is essentially self-taught, although he did attend my evening classes for a couple of years.

At Workbridge, service users, staff and volunteers (including Jim Bassett, *q.v.*) collaboratively produce a variety of ceramics. Rob oversees a system that enables people of diverse abilities to participate in the making processes. Products are sold both in their own shop and to wholesale customers.

Working methods

Work is slipcast using Valentine's RBC60 clay that is blunged, with water, sodium silicate and sodium carbonate added to make the slip. While much of the output is designed for garden use, the pottery also produces a range of ware decorated with slips and engobes. These are brushed onto the cast terracotta pieces in different layers using the wheel. Sometimes further layers are applied using sponging and stencilling; wax and paper resist techniques are also employed. Rob finds that the final appearance of the engobe is profoundly affected by the thickness of application.

Rob says, 'My approach to ingredients and slip/engobe recipes is a little experimental – we enjoy the surprise of the outcome!' But he

Rob Burgess at Workbridge Ceramics applying engobe to a money box. PHOTOGRAPH BY ROB BURGESS.

adds that his notes help him to repeat successes. He uses white slip with underglaze stains and/or oxides added in various percentages to blend further colour. For the standard engobe, he mixes the white slip with soft borax frit (Potclays 2264, 30% slip, 70% frit); this can be mixed with any of the slips in varying percentages.

Technical information

Clay Valentine's RBC60 with added sodium silicate and sodium carbonate.

Slips White slip (either white earthenware clay or Potclays white earthenware casting slip) with underglaze stains and/or oxides.

Pre-mixed decorating slips from Potclays and Potterycrafts.

Engobe

Slip	30
Soft borax frit (Potclays 2264)	70

* This can be mixed with any of the slips in varying percentages.

Firing The workshop has two 18 cu. ft truck kilns by Kilns and Furnaces, and one 2.5 cu. ft Amaco, which is used for test firings or if anything is needed in a rush. Rob single-fires at 100°C (180°F) an hour to 600°C (1112°F), then 150°C (270°F) to 1145°C (2093°F) followed by a 20-minute soak.

Rob Burgess at Workbridge Ceramics. Fired money box with engobe decoration, (h. 21 cm/ 8¼ in.). PHOTOGRAPH BY ROB BURGESS.

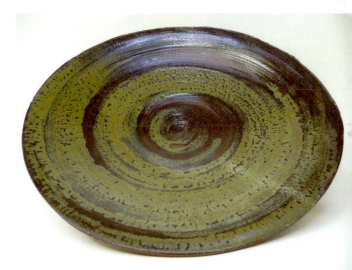

Right: Rob Burgess at Workbridge Ceramics. Birdbath with engobe, (d. 37 cm/14½ in.). PHOTOGRAPH BY ROB BURGESS.

47

Ellen Rijsdorp
(THE NETHERLANDS)

Ellen Rijsdorp has an international reputation for her work in raku, and has exhibited widely in the UK and mainland Europe. However, health problems forced her to change direction. Whilst Ellen uses glaze on the outside of her pots, I have included her in this section because the dominant surface is that of the unglazed slip.

Following ceramics courses at college Ellen taught in several cultural and ceramic centres in Delft for twelve years, and in 2007 she opened her own gallery, BisQceramics, in the heart of that city.

Ellen is philosophical about the health problems resulting from her time as a raku potter. 'It forced me to think of other firing techniques. It gave me lots of opportunities and I was free to start again.' Her new work evolved from her raku pieces, but instead of flat areas the shapes are now rounded, which she finds more suitable for her decorative technique.

Working methods

Ellen works on the wheel and is an expert thrower. Her vessels, which vaguely resemble doughnuts, are thrown upside down, and with a double wall. The inner wall is a tapering inverted cone shape that will eventually become the central well in the finished piece. The outer wall is entirely closed over this; the air pressure inside can help in the shaping of the doughnut.

When the pot is firm enough to handle, it is rested on a plastic bowl with a rounded edge so as not to cause damage, and different coloured slips incorporating body stains are applied. The following day (when the slip has dried) the bowl is secured on the wheel with pellets of clay, and with a metal kidney held at right angles to the surface, 'chatter'

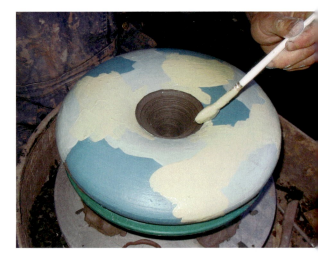

Ellen Rijsdorp painting coloured slips.
PHOTOGRAPH BY RICHARD JONKER.

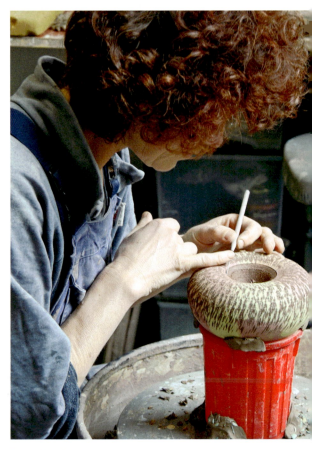

Ellen Rijsdorp making 'chatter' marks through the slip layer. PHOTOGRAPH BY ERIC SCHOEVERS.

marks are made in the pot as the wheel rotates. These marks cut through the slips to reveal the body clay beneath.

The pots are stacked on top of each other for biscuit-firing to 980°C (1796°F) in a top-loading kiln, and then glaze is applied by brushing. Some two hours or so later, when the glaze has dried, it is scraped off, leaving a residue in the indentations. Glaze-firing is to 1220°C (2228°F).

Technical information

Clay PRGF 'Gris' from Ceramica Collet, distributed by WBB Fuchs – a 40% chamotte clay (0.0–0.05 mm).

Slips & glaze Ellen's own formulations. Slips using body stains in the base slip, with matt glazes.

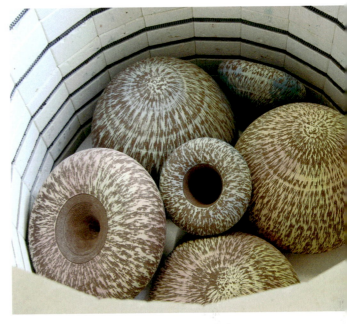

Ellen Rijsdorp – pots stacked in the kiln for firing. PHOTOGRAPH BY ERIC SCHOEVERS.

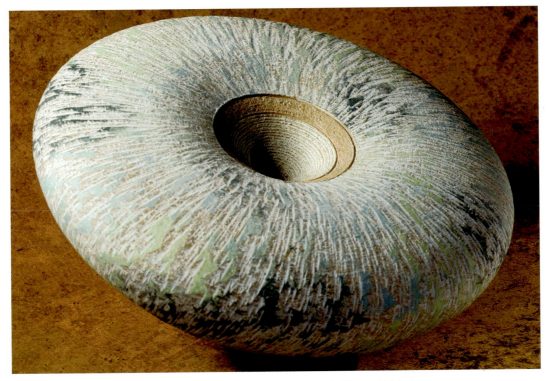

Doughnut form by Ellen Rijsdorp with 'chatter' decoration, (d. 30 cm/12 in.). PHOTOGRAPH BY HERMAN ZONDERLAND.

Sasha Wardell (UK)

Sasha Wardell is unusual amongst studio potters in that she slip-casts in bone china, a notoriously intractable material. She is the author of *Slipcasting*, published by A&C Black in the Ceramics Handbook series, and of *Porcelain and Bone China* (Crowood).

Drawn to the whiteness and translucency of bone china as an undergraduate, Sasha was able to investigate industrial methods of using this material whilst working for her MA. She also studied in France, spending some years there before returning to the UK. She has exhibited and demonstrated in numerous countries, and her work is held in many international public collections.

Everything Sasha makes is slipcast, and she does not use glaze. She has 'adapted the industrial techniques associated with bone china production, of mould-making and slip-casting, to studio production'. Along with the whiteness of the material, her primary concern is with its translucency and enhancing the 'differing degrees of luminosity' that are possible. She finds the limitations and restrictions of working with it a creative challenge.

Working methods

Slip casting with bone china is difficult – any accidental distortion during making may be retained in the clay's plastic memory to re-emerge during firing, and it is fragile at all stages until it has been high-fired. Accepting these challenges, Sasha has developed several decorating techniques to use with bone china.

One method involves building up three or four layers of different coloured slips in a plaster mould. Slip is poured into the mould and emptied immediately. When the sheen has disappeared, the next layer is added and the process continued until the requisite number of layers has been achieved. The piece is removed from the mould when bone dry. Facets are then very carefully scraped through the layers with a sharp blade to reveal concentric rings of different colours. After biscuit-firing the piece is wet-sanded using very fine 'wet and dry' paper, fired to glaze temperature with a long soak to ensure maximum translucency, and then polished again with 'wet and dry' paper.

The same layering process is used for pots where an incising technique is employed – essentially a type of sgraffito. A loop tool is used to gouge marks through the layers, revealing the different colours, while the incisions give movement to the pot.

By applying an acrylic resist medium to build up patterns on the surface of a single-colour cast, Sasha is able to use a 'water erosion' technique in which the piece is very carefully washed with a damp sponge. Some of the unprotected clay is removed in each washing, resulting in different degrees of translucency after the final firing. Colouring the resist medium can help to identify the design.

Technical information

Slip Valentine's bone china slip, with commercial body stains for colour.

Firing Work is biscuit-fired to 1000°C (1832°F) and high-fired to 1260°C (2300°F) with a one and a half-hour soak in an electric kiln.

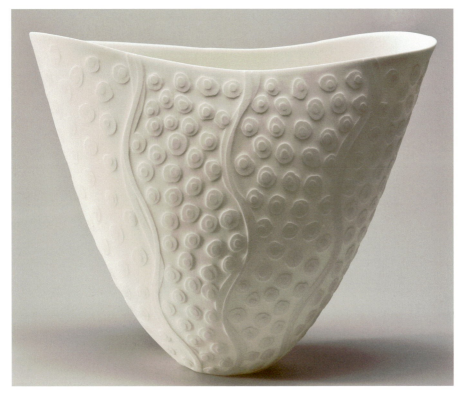

Ripple Bowl by Sasha Wardell, slipcast bone china, water erosion technique, (h. 18 cm/7 in.). PHOTOGRAPH BY MARK LAWRENCE.

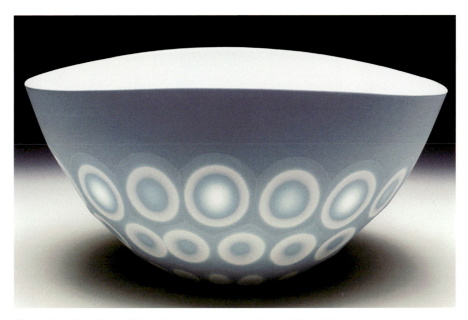

Space Bowl by Sasha Wardell, slipcast bone china with multiple layers and cut facets, (d. 38 cm/15 in.). PHOTOGRAPH BY SEBASTIAN MYLIUS.

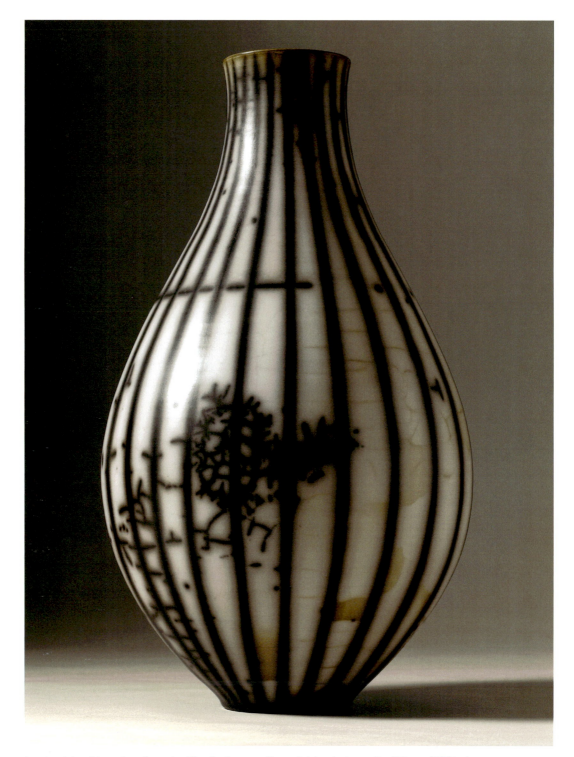

Large striped teardrop form by Tim Andrews, slip-resist technique, (h. 70 cm/27½in.). PHOTOGRAPH BY DAVID GARNER.

6 Slips and Raku

As a technique, raku seems to encourage experimentation. The immediacy of the process, and the relatively rapid turnover compared to conventional firing methods, encourages this. Given that it is often a group activity, perhaps with an audience, it can even be seen as a theatrical event, with dramatic outcomes. Certainly the variety of approaches to be found in contemporary raku is extremely wide – when teaching I have used *Raku* by Tim Andrews (see Bibliography) more than any other book to illustrate different directions a student might follow.

Slips are used in raku to enhance the surface quality, for instance by using a finer clay slip over the coarse raku clay. Oxides and body stains can be added to give colour, a feature of Ashraf Hanna's work. Steven Branfman uses slip to give varying textures to his pots while they are on the wheel.

Slips are also used in different ways by both Tim Andrews and Ashraf Hanna with a technique known as 'slip resist'. The biscuit-fired pot is coated in clay slurry through which a pattern is drawn. When the hot pot is placed in the reduction chamber (e.g. in sawdust) after firing, smoke penetrates these lines and marks the pot. The fired clay slurry is subsequently removed from the pot.

Because of the low firing temperature normally used in raku, slips may not bond well with the body clay, a characteristic which is exploited in slip resist – in fact it was how the technique was discovered. A slip applied by dipping (as you might for stoneware or earthenware firing) may lift off the raku body like the shell from a hard-boiled egg. In order to avoid slip coming away from the body, I suggest that you (1) use a slip similar to the clay body but sieved to remove the grog; (2) apply slip when the pot is still wet or soft; or (3) burnish the slip to compress the join and ensure good adhesion.

Tim Andrews (UK)

After a one-year apprenticeship with David Leach at Lowerdown Pottery, Tim spent two years at Dartington Pottery training workshop. When he set up his own studio he initially made domestic ware and individual pieces in stoneware and porcelain. However, partly because he wanted to offer a varied teaching programme, and because he felt his work needed a new direction, his thoughts centred on raku. He had experimented with it in his late teens – in his book *Raku* there is a delightfully amusing account of his 18th birthday celebrations, which centred on a raku firing.

Today, Tim's pieces are in major public and private collections around the world. He has conducted workshops in a number of countries, and his book *Raku* (see Bibliography) is a definitive work on the subject. Beautifully illustrated and written in accessible English, it is the book I have used most in my teaching. In addition, Tim has produced an excellent DVD entitled *Tim Andrews: Raku and Smoke-fired Ceramics*. His recent work has included sculptural items as well as thrown pieces.

Working methods

Most of Tim's work is made on the wheel, though some is slab-built. He employs a variety of raku techniques; however, here we are interested in his use of 'resist slip'. In using this process, Tim is exploiting the fact that the slip will not form a strong bond with the pot, but is instead used to create a layer which can be removed after firing.

After throwing and turning, many of Tim's pots are given a coating of porcelain slip, which may be coloured with the addition of body stains. This layer is burnished with a pebble or the back of a spoon to a silky finish before biscuit firing.

After biscuit firing, the desired pattern is built up on the pot using masking tape and/or wax resist. Resist slip is brushed on top of this, followed by a layer of glaze (which *must not* be allowed to touch the pot's surface), and the masking tape peeled away to reveal the design. The intention is that the slip-glaze layer resists carbon penetration during reduction – the smoke can only penetrate and blacken the clay along the lines created by the pattern.

When the pot has cooled the slip/glaze layer is removed, a process very similar to shelling a hard-boiled egg. Places where the smoke has penetrated will be revealed as

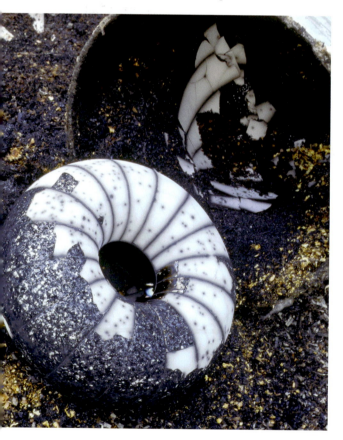

Large doughnut form by Tim Andrews after reducing in sawdust, with the resist slip and exposed areas clearly visible. PHOTOGRAPH BY TIM ANDREWS.

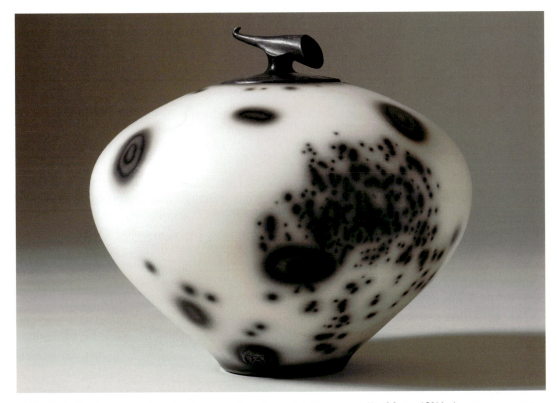

Lidded 'Curling' piece by Tim Andrews, using slip-resist technique (h. 22 cm/8¾ in.). PHOTOGRAPH BY DAVID GARNER.

black lines, and where the clay has been largely protected from the smoke it will be white (or the slip colour). There should also hopefully be random areas that have been partially affected, adding further interest to the piece.

Note: The fragments of 'eggshell' can have a sharp glaze edge, so be careful when handling, and use gloves if necessary.

Technical information

Clay A 50:50 mix of porcelain and T or Y Material (more T or Y Material is added for larger pieces.) A porcelain slip is used over the body as it is easier to burnish, is whiter (or coloured with commercial stain), and is less prone to absorbing vast amounts of smoke. Occasionally neat porcelain is used for smaller pieces.

Slip **Resist slip**

China clay	1
Flint	1

Tim sometimes adds a handful of aluminium hydroxide (batt wash) to a large bucket of slip to increase its refractory qualities.

Sugar can be added to the resist slip for 'candy raku' – it burns as the pot fires and can give interesting smoke effects.

Tim occasionally adds some copper oxide or carbonate to the resist slip, which can produce an attractive pink blush. However, he points out that both the copper and the sugar tend to make the slip more difficult to remove.

Firing Biscuit firing is around 980°C (1796°F), and higher for pieces with greater porcelain content. Resist-slip pieces are glaze-fired to around 900°C (1652°F) – the glaze does not need to mature fully.

Steven Branfman (USA)

I know a number of potters who discovered pottery entirely by chance, but Steven's has to be the most bizarre encounter. When he was at art school majoring in sculpture he was required to take a 'craft' course – the school offered ceramics, glass, jewellery, metal, textiles and weaving amongst others. Not having any preference or bias, Steven wrote the names of all the courses on slips of paper, pinned them to his bedroom wall, stepped back, closed his eyes, and threw a dart! 'It landed on ceramics. Not near ceramics. Not in between two slips of paper so I had to measure the distance. It landed on ceramics and the rest is history.'

Born in California, Steven grew up in New York City in a family environment strongly influenced by art. It was at college that Steven decided to become a potter, and after completing his master's degree he established his studio and The Potters Shop and School in Needham, Massachusetts. He is the author of three books on ceramics (see Bibliography).

Although Steven's work is mainly raku and therefore non-functional, it is vessel-oriented; he likes to maintain the connection between contemporary pottery and ceramic history. He emphasises the importance of the surface texture of his vessels – carving, incising, impressing, combing, the addition of wet and dry clay, grog or sand are all used in this. After texturing the thrown pot, the vessels are expanded from within so that the outer skin stretches and takes on its own character, while the kiln and subsequent reduction in combustible materials bring further changes.

Working methods

Steven's pots are all thrown on two Shimpo wheels, the newer of which is 30 years old; both are 'smooth as silk'. Larger pieces are made using the 'coil and throw' method in which a thick sausage of clay is added to the thrown and partly dried lower section and then pulled up. Texturing, as described above, is very important.

After biscuit firing in an electric kiln, pots are glazed using both commercial low-fire glazes and others made to Steven's personal recipes. His kiln of choice is a recycled electric kiln fired with LPG; however, he has several others, including a 'very well-built' top-hat kiln from Ceramic Services in California.

Glaze-firing is done by observation only, without pyrometer or cones, and depends on the degree of melt Steven wants for a particular pot – the finish can vary from matt to high gloss. Work is removed from the kiln with tongs and then sprayed with water to lessen the chance of metallic lustres forming, and to brighten the glaze. Post-firing reduction is done in tight-fitting metal canisters with lids – the smallest can that will accommodate the piece – and work left to cool completely before the can is opened. Only a small amount of reduction material – wood shavings, coarse sawdust or pine needles – is used.

Technical information

Clay Laguna #250 – an off-white, very smooth-textured clay specially formulated for raku, which Steven says gives 'excellent plasticity, outstanding throwing body.'

Slips Steven uses a variety of slips, including Redart, which are applied to the wet surface of the body during throwing.

Glaze **Roger's white**

Spodumene	35
Gertsley borate	60
Tennessee ball clay	5

This is a clear glaze that is white over white clay. Any ball clay can be substituted for the Tennessee ball clay.

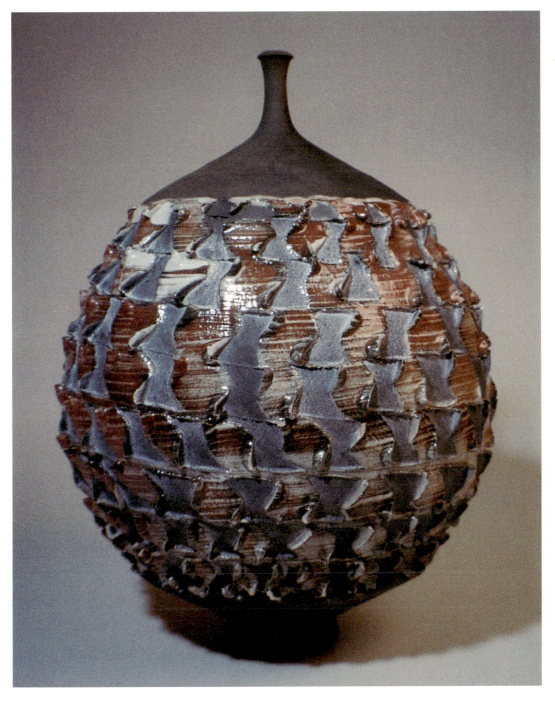

Firing Work is biscuit-fired to cone 08 (950°C (1742°F) in an electric kiln. Glaze firing is done by eye to approximately 980°C (1800°F).

Raku vessel by Steven Branfman with applied slip texturing, (h. 40 cm/15¾ in.). Collection American Museum of Ceramic Art, Pomona, California. PHOTOGRAPH BY STEVEN BRANFMAN.

Ashraf Hanna (UK/EGYPT)

Ashraf Hanna makes individual handbuilt vessels and sculptural forms with geometrical and burnished surfaces that are fired using raku techniques.

Ashraf studied at the El Minia College of Fine Art in Egypt, but he was introduced to clay by his now wife Sue in London, and at her own studio. Throwing was something of a disaster, but he took to handbuilding, and is now amongst the leading potters in this field. Inspired by Jane Waller's book *Hand-built Ceramics* they started experimenting with burnishing and smoke firing. A workshop/holiday with Alan Bain, a Scottish ceramicist living in Greece, proved inspirational; Alan introduced Ashraf to building with large slabs, the technique he now uses to make all his work.

Two other books proved to be great sources of information – *Raku*, by Tim Andrews, and *Smoke-fired Pottery*, by Jane Perryman. However, living in Hackney meant there were constraints on the types of firing Ashraf could experiment with, and he felt he did not have enough knowledge to use raku kilns and glazes. Instead he developed the slip-resist technique known as 'naked raku' (see working methods); all his work since 2003 has been fired this way.

Working methods

Forms start as a pinch pot and are then developed using slabs. I have heard this technique referred to as 'coiling with slabs'. The completed pot is then refined using rubber and metal kidneys.

Ashraf stresses that burnishing is very important to the final result; he uses slip on all his burnished surfaces. Each layer of slip, brushed on at the leatherhard stage, is polished using smooth pebbles, with three or four layers being added. Contrasting carved and burnished areas are a feature of this artist's work.

Linear designs are carved into the clay at the leatherhard stage, or by using the naked-raku technique – after biscuit-firing the pot is covered with a thick layer of slip; once this is dry, a thin layer of glaze is brushed on and the pattern drawn through the slip/glaze layer. Gum arabic is added to the slip to aid adhesion. The pot is fired until the glaze has matured, at which point it is removed from the kiln, placed in the reducing chamber, and covered with sawdust. The carbon penetrates the design, producing black lines and leaving covered areas relatively unmarked. Once the pot has cooled the slip/glaze layer can be removed.

For more information about this technique, see the section on Tim Andrews in this book, and books on raku by Tim Andrews and John Mathieson listed in the Bibliography.

Technical information

Clay Earthstone Professional Ashraf Hanna Raku Body – available from Scarva Pottery Supplies and Valentine Clays.

Slips Ashraf uses the ball clay from his raku body, which is sieved to remove the coarse particles of Molochite.

For colour, commercial stains are added by eye.

Firing Biscuit-firing is to 1000°C (1832°F) in an electric kiln, raku glaze-firing to 850°C (1562°F) or until the glaze has matured.

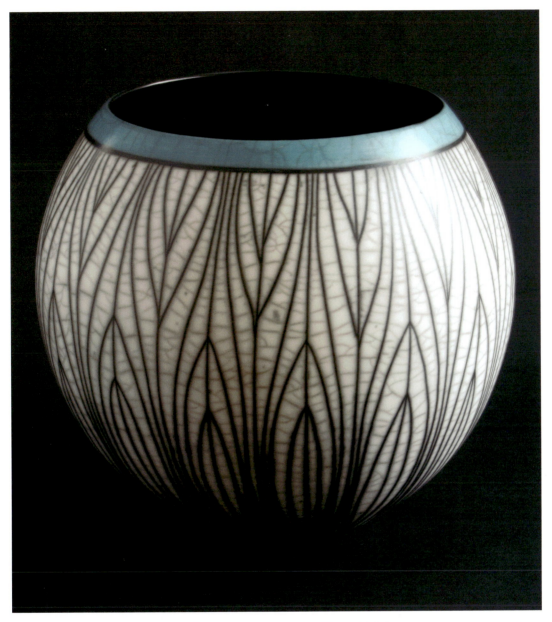

Bowl by Ashraf Hanna, burnished slip, slip-resist firing, (h. 28 cm/11 in.). PHOTOGRAPH BY ASHRAF HANNA.

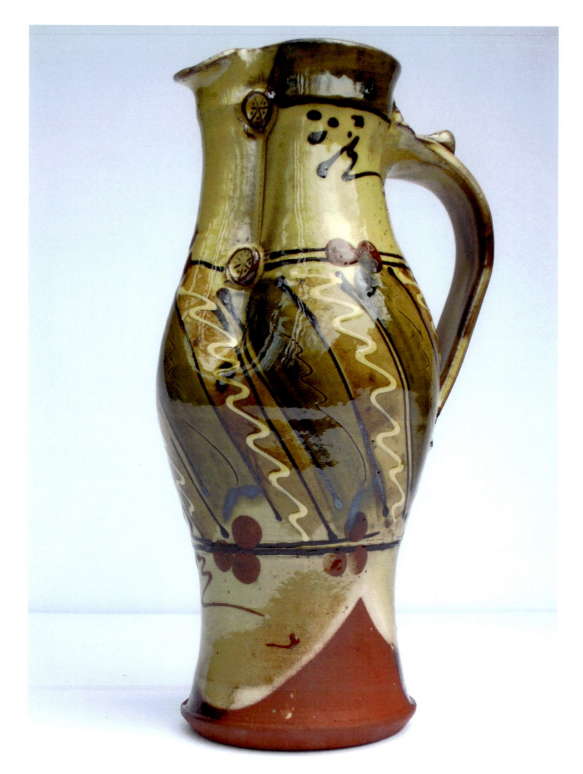

Jug by Niek Hoogland, (h. 32 cm/12½ in.), see p.88. PHOTOGRAPH BY NIEK HOOGLAND.

7 Slips with Glaze at Earthenware Temperatures

Historically, most of the world's pottery has been earthenware, and it is at earthenware temperatures (1050–1150°C/1022–2100°F) where we find the greatest use of slips. Approaches vary from the elegantly functional work of Jennifer Hall and the painterly pieces of John Pollex to Ross Emerson's brightly coloured clocks and Dylan Bowen's Zen take on slip trailing. Some work has more traditional foundations, but is nonetheless individual,

such as Paul Young's celebration of slip decoration on his chargers and figures, and James Bassett's commemorative dishes. Other work is distinctly contemporary, as seen in pieces by Michael Eden and Richard Phethean.

Many potters working in this temperature range use lead glazes; all use safe forms of lead if they think food may come into contact with the work. Please see p.137 for more information.

Bottles by Dylan Bowen, (h.15 cm/6 in.). PHOTOGRAPH BY BEN RAMOS.

Richard Phethean (UK)

Richard Phethean has established an international reputation as both a maker and teacher; he has taken slipware into totally unexpected areas with his dynamic and expressive work. While he originally made domestic ware, he now sees himself as a sculptural potter. However, there is a continuity to his work – elliptical shapes that were once serving dishes today have rough edges and slab additions, while jugs, often very tall, are made from thrown sections, with slabs added for the spout and handle. The coarser clay, which replaced the smoother domestic body, is given its own voice, both through the glaze and in areas left exposed.

As a 15-year-old, Richard saw the work of Scott Marshall (who had trained with Bernard Leach) at his pottery near Land's End; he remembers his fascination, and regards the visit as a pivotal moment. Later he trained at Camberwell School of Arts and Crafts, and in the studios of Colin Pearson and Janice Tchalenko. He also spent two years with Voluntary Service Overseas running a cultural centre in Papua New Guinea with 30 staff and three workshops specialising in domestic pottery, textile printing and rug weaving. The impact of his time there was 'overwhelming, both emotionally and politically', and led to a reappraisal of his work as a craftsman.

On his return to the UK Richard ran a workshop in south London for some time, later moving to a Quaker school in Oxfordshire. He is also visiting lecturer and module leader in throwing on the internationally renowned Harrow degree course, and runs his own intensive throwing courses every summer. His book *The Complete Potter – Throwing* was published in 1993, along with the video *An Introduction to Throwing*, designed to complement the book.

Working methods

Richard tends to work on themes, which include sculptural teapots, tall jugs, vases, dishes, and bowls up to 60 cm (24 in.) wide (some with rims cut to form a hexagon), pedestal bowls, leaning coffee mugs, tea bowls and slabbed dishes. He mainly uses a combination of throwing with slab and flattened coil additions, with some dishes being press-moulded. Work is frequently built up from thrown sections, which are sometimes pressed into an oval. Slab-rolled extensions are added, while handles can be made from slabs or from coils that have been pressed flat. Areas of clay that are to be left unglazed are freely marked.

Slips are brushed onto the clay at the leatherhard stage, with the first layer, usually white, being left to become touch-dry before the second layer, usually blue, is applied. Brushmarks are a major feature, with different thicknesses of overlapping slip combining with the brush texture to give varying densities of colour, with more or less of the red body showing through. A line may be slip-trailed – accidentally splashed dots are welcome – and sgraffitoed using a broken hacksaw blade.

Richard also uses 'paper resist', in which shapes cut from newspaper are dampened with water and then pressed onto the surface of the pot. This may be over a layer of slip, or directly onto the bare clay. Slip is then painted over the pot, and the paper carefully peeled away to reveal the geometrical pattern (see the large jug form by Richard Phethean on p.17).

After biscuit firing, areas of exposed red clay that are to be left unglazed are painted with the blue slip. This is then sponged off, leaving a very thin residue on the smooth clay, with more being retained in textured parts. These sections, and the dark-blue slip applied at the leatherhard stage, are painted

with wax resist, with great care being taken not to cover any of the white slip. Because of the high cobalt content, the blue slip fuses to the body, giving a semi-matt surface after the glaze-firing.

Richard uses both honey and clear glazes, which are applied by pouring and dipping.

Technical information

Clay Valentine's Terracotta Sculpture

Slips **White slip**

Hyplas 71

Blue slip

Hyplay 71 100

Cobalt oxide 10

Richard emphasises that cobalt oxide is stronger and is more speckled under the glaze than the carbonate.

Glazes **Honey glaze**

Lead bisilicate 74

Potash feldspar 11

Powdered red clay 10

Borax frit 5

Bentonite 4

Iron oxide 3.5

Clear glaze

As for honey glaze, but without the iron oxide, and with ball clay substituted for red clay.

Firing Richard biscuit-fires to 1030°C (1886°F) and glaze-fires to 1120°C (2048°F) in an electric kiln. The biscuit temperature (slightly higher than normal) reduces porosity; less glaze adheres to the pot, with the resulting thinner fired glaze being less prone to crazing.

Jug form by Richard Phethean, thrown with slab additions, wax resist, transparent glaze, (h.45 cm/17¾ in.). PHOTOGRAPH BY JOHN MATHIESON.

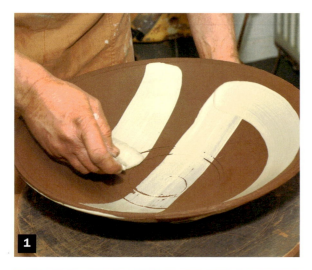

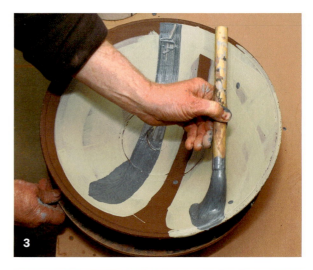

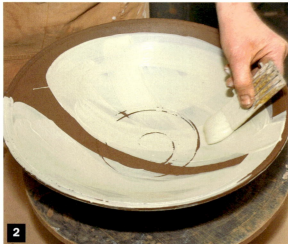

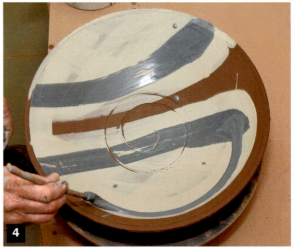

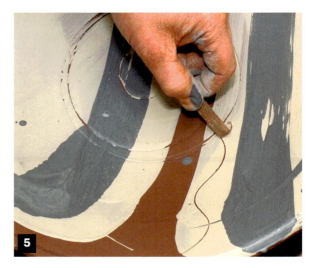

Photo sequence following Richard Phethean decorating the same bowl through two firings.
ALL PHOTOGRAPHS BY JOHN MATHIESON.

1 Richard Phethean painting white slip on the bowl.

2 Painting in blocks of white slip on the bowl.

3 Painting blue slip over the white slip.

4 Painting broad and thin brush strokes of blue over the white slip.

5 Making a sgraffito line with a broken hacksaw blade.

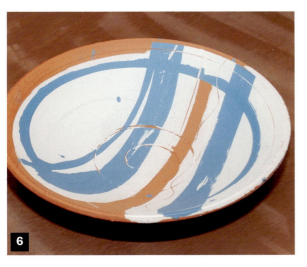

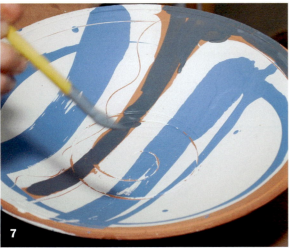

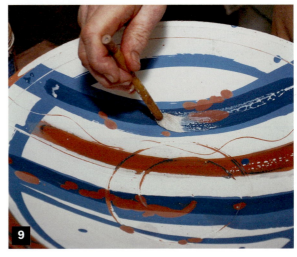

6 The biscuit-fired bowl.

7 Painting blue slip on the biscuit-fired bowl.

8 Sponging off the blue slip.

9 Painting wax on the blue slip.

10 Pouring glaze over the bowl.

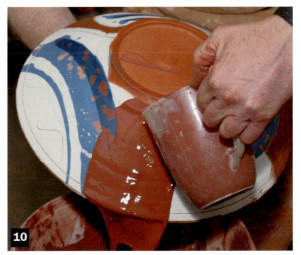

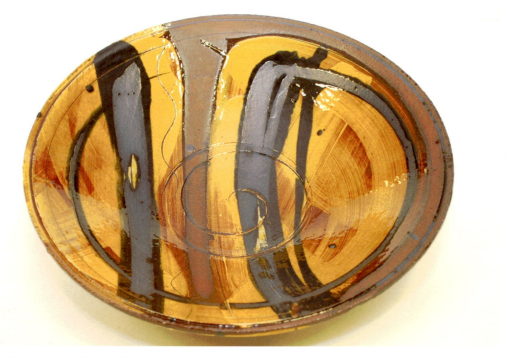

The finished bowl by Richard Phethean, honey glaze, (d. 38 cm). PHOTOGRAPH BY JOHN MATHIESON.

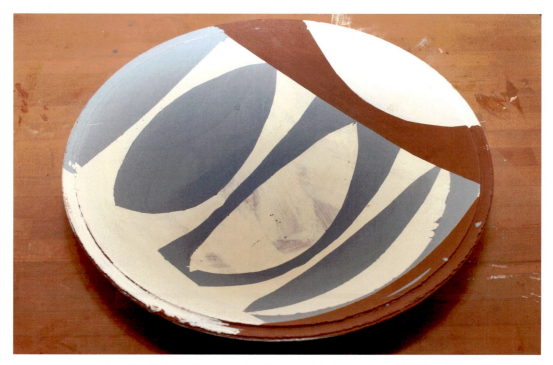

Large greenware bowl by Richard Phethean (d. 50 cm/20 in.), paper resist (blue slip over white).
PHOTOGRAPH BY JOHN MATHIESON.

James Bassett (UK)

James Bassett was introduced to pottery as part of his teacher-training course at Cheltenham; the nearby Winchcombe Pottery was used as an exemplar of sound practice. Student visits were conducted by the enthusiastic Sidney Tustin, who began working at the pottery with Michael Cardew in 1926, retiring in 1978. When he left college James was convinced, as were many people at the time, that there were only two types of pots worth making, reduced stoneware and lead-glazed earthenware. He experimented with slip trailing, and this lead to him making the first of over 150 mainly commissioned commemorative slipware chargers, a plate to mark the birth of his daughter.

Working methods

James finds the colour range of the basic terracotta clay, a darkened version (black) and a contrasting white slip under a unifying honey glaze 'harmoniously very satisfying'. 'Simple blends of these slips on the black background can offer rich and varied combinations.' His extensive research into the great 17th-century chargers convinced him that their quality lay in the density of their decoration, with all kinds of shapes and devices employed to fill the spaces between images or words. He especially notes the 'brightness and sparkle' often achieved by the use of tiny white dots in the main outlines of a design. And whilst his chargers are within the tradition of English slip trailing, he has carefully avoided slavish copying to produce a body of work very much his own.

Right: Slip-trailing sequence by James Bassett.
PHOTOGRAPHS BY JOHN MATHIESON.

1 Marking a guideline on a plate.

2–3 James Bassett lettering.

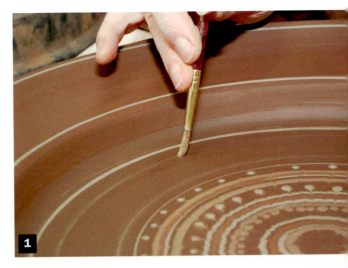

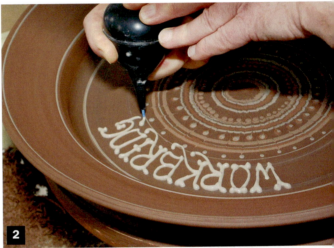

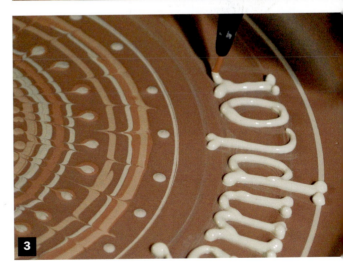

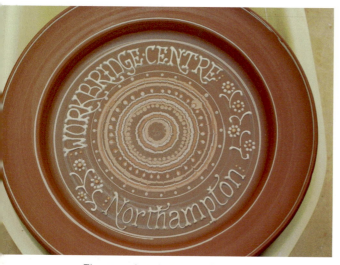

The completed plate by James Bassett.
PHOTOGRAPH BY JOHN MATHIESON.

James prefers to write mainly in Roman capitals, adapting that alphabet for slip. He emphasises the importance of serifs – slight projections that finish off the stroke of a letter. The letter 'I' can be transformed by the addition of two very small dots at the top and bottom, and perhaps another in the centre. He pulls down the crossbar of the letter 'A' to fill the space. And, unlike Toft, he does 'draw the line at writing some letters backwards' and he also 'endeavours to spell most words correctly'! Looking at James's work, it often seems that his approach is to make each letter fill a rectangular space, with a different rectangle for each letter. But he points out that, working on a circular plate, each letter has to fit into a wedge shape and is adapted accordingly. The legs of an 'H' are never parallel, while the letter 'T' gets a wide bar at the top of a plate, but a narrow one at the bottom.

James marks guidelines onto the leather-hard background slip with a brush using very watery slip – the faint mark will be lost with the fusion of the glaze into the slip. Lettering can be planned using the same technique.

For very detailed work James inserts a short length of plastic insulation (stripped off a domestic electric cable). (Some pottery supply houses now offer slip trailers with five or six interchangeable nozzles.) He sieves the slips for each day's work, and suggests that sieving lightest to darkest can save washing in between. He wipes the tip of the trailer on a sponge, and extrudes a small quantity of slip at every use to ensure there isn't a bubble waiting to spatter the work. (Some potters keep their trailers upside down on a rack once they have been filled for this reason.) James uses thick slip for trailing – it stands proud of the background, and though some of this will be lost through drying and the slight smoothing effect of the glaze, these variations in surface add further interest by reflecting the light in different ways.

Mistakes can be rectified by rolling the wrong letter up on a damp watercolour brush; any traces left in the background slip will be fused into the glaze and lost.

Technical information

Clay body A variety of red earthenware bodies.

Slips	Black background/lining slip	
	Red body	5 pt (3 l)
	Red iron oxide	2 oz (60 g)
	Manganese dioxide	2 oz (60 g)
	Trailing/lettering slips	
	Yellow – Potclays Standard Buff (fits most bodies)	
	Red – body clay	
	Orange – Buff slip	3
	Red slip	1

Note: Jim says that making your slips out of clay blended for throwing seems to result in fewer compatibility problems than using ready-made coloured slips with unknown constituents.

Glaze	Lead bisilicate	80
	Dry red-clay body	20

Firing	Work is biscuit-fired to 1020°C (1868°F), and glaze-fired to 1100°C (2012°F).

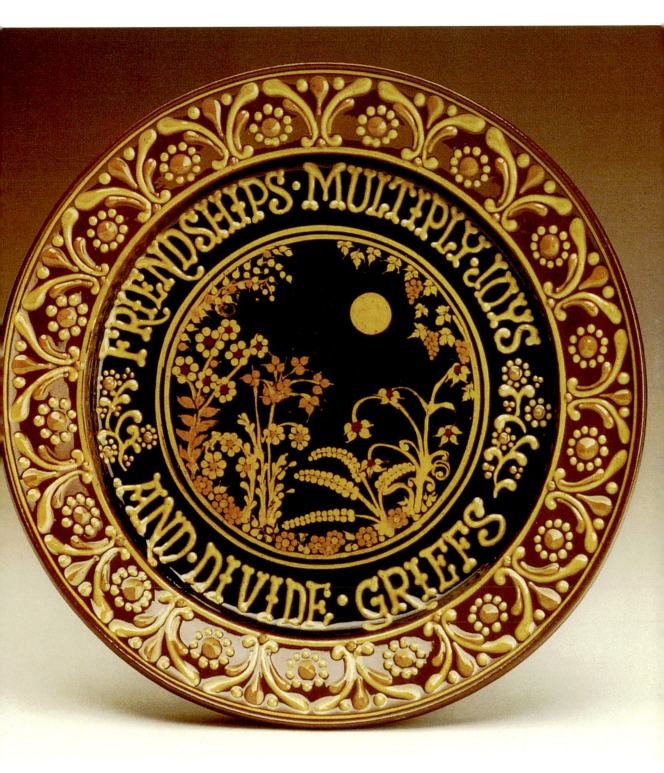

Friendship plate by James Bassett, (d. 40 cm/15¾ in.). PHOTOGRAPH BY JAMES BASSET.

Jennifer Hall (UK)

Jennifer Hall makes a range of elegant domestic slipware and some individual pieces, work that she hopes will 'comfort, reassure, and bring warmth and pleasure' to the user.

On the foundation course at the West Surrey College of Art and Design, Jennifer was initially intending to study sculpture but during a visit to a Cardiff college to see the sculpture department she was captivated by a display of ceramics. 'The colourful sculptural and functional ceramics appealed to me in a way that fine art did not.' This exposure to clay led to her taking a degree in Ceramics at Cardiff. She is drawn to earthenware 'because of its warmth of colour and softness of edge'; in addition, she is interested in making and decorating rather than in the firing process.

Function is the most important factor in deciding form, with inspiration coming from glass, metal and clay objects, both ancient and modern. She likes her work to be affordable, feeling strongly that 'functional pots should have functional prices'.

Working methods

Jennifer throws on a geared kickwheel – she enjoys the immediacy of this way of working, and the boundaries it sets. As she dislikes turning, she has developed a range of thrown shapes without turned foot-rings. Ribs form a ridge at the base of many of her pots, which not only finishes the line, but also gives somewhere to grip the pot when dipping in slip or glaze.

At first her decorations were mainly leaf motifs that covered the various forms; now she is much more restrained in what she does. Slips are applied at the leatherhard stage by pouring and dipping; the slip is sometimes used quite thinly, allowing gradations of the red clay to show through. Different colours of slip may be brushed or

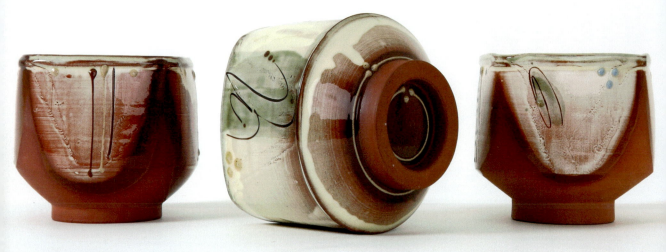

Teabowls by Jennifer Hall, (h. 11 cm/4¼ in.). PHOTOGRAPH BY NIGEL BEVAN, ASCARI PHOTOGRAPHIC.

trailed over this, and rims banded to provide a highlight. Sgraffito lines may be added, often through brush marks to compliment their shape. 'Nothing is laboured over, as I believe the decoration is at its best when executed rapidly and with confidence.'

Technical information

Clay Potclays Roche Red

Slips **White slip**
Potterycrafts P1521 White Throwing Earthenware body

Blue slip
1 cup of white slip to 1 teaspoonful of cobalt carbonate

Ochre slip
7 parts white slip to 1 part black slip

Black slip

Red clay	90
Manganese dioxide	10
Red iron oxide	5
Flint	5

Red slip
1 cup of slops from the wheel to 1 teaspoonful of red iron oxide

All slips are sieved once through a 100s mesh sieve, except blue and white, which are sieved twice.

Glazes **Honey glaze**

Lead sesquisilicate	75
China clay	18
Flint	7
Iron oxide	3

Transparent glaze

Lead sesquisilicate	75
China clay	18
Flint	7
Iron oxide	0.375

Note: Both the honey and transparent glazes are variations of Mary Wondrausch's recipe.

Firing Jennifer biscuit-fires to 1000°C (1832°F) with a 15–20 minute soak to avoid pinholing in the glaze. The glaze firing is to 1055°C (1931°F) with a one hour and 45-minute soak.

Handled form by Jennifer Hall, (w. 38 cm/15 in.). PHOTOGRAPH BY NIGEL BEVAN, ASCARI PHOTOGRAPHIC.

Ross Emerson (UK)

Ross Emerson makes a range of decorative one-off pieces – vases, candelabras, and large dishes – but he is best known for his quirky clocks. Leaning, twisted, vividly coloured, and with an element of surrealism, they surprise and delight the viewer.

Ross comes from an artistic background – his father was a painter and senior lecturer at Exeter Art College. Ceramics was the first activity to really interest him during his foundation year, and he subsequently went on to study 3D Design in Ceramics at Loughborough University. At college he was

more interested in making rather than decorating, an attitude he maintained for a long time.

After two years at Dartington Pottery Ross spent some time in New York State, where he was required to decorate porcelain. He discovered that, not only did he enjoy doing brushwork, he also 'got quite good at it'.

On his return to the UK, Ross made oil-fired stoneware with the brush decoration he had developed in the States. But this was the early eighties, not a good time for studio pottery, and within three years he had gone out of business. He then didn't touch clay for seven years until he spent a week experimenting at West

Ross Emerson applying slip. PHOTOGRAPH BY ROSS EMERSON.

Ross Emerson decorating with slips. PHOTOGRAPH BY ROSS EMERSON.

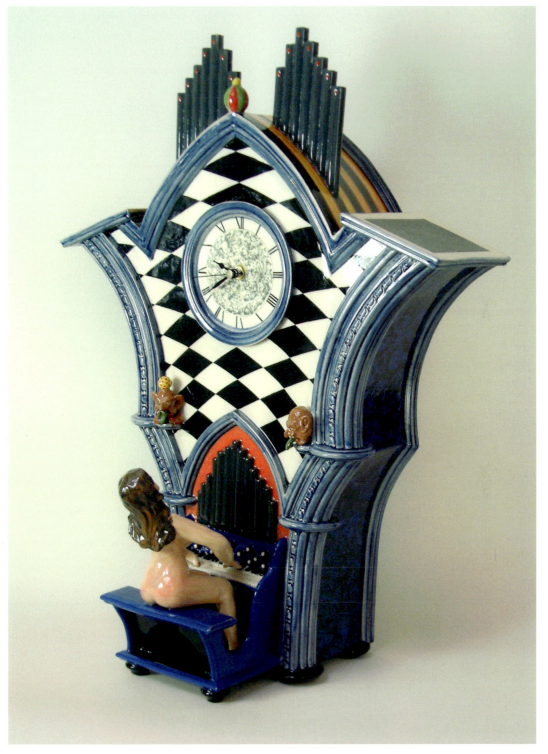

Naked Organist, clock by Ross Emerson (h. 56 cm/22 in.). PHOTOGRAPH BY ROSS EMERSON.

Dean College. This led to slab-building in red clay, and to making his clocks.

Influences can come from anywhere – Ross quotes architecture, antiques, funfairs, gipsy caravans, and abstract art, though Marc Chagall is his favourite painter.

Working methods

When he first started making his clocks, Ross was painting a 50:50 glaze to stain mix onto the already glazed pot, which had been slipped with white ball clay (Hyplas 71) prior to biscuit firing. The mix was never properly measured, but was repeatable. The technique allowed layering of colour on colour, sometimes with sponge and wax resist as well as brush.

This method has changed. Today, Ross mixes the stains in the same 50:50 ratio, but now as a slip that is applied to the white-slipped but unfired clock. He says, 'This change has revolutionised my work. Instead of the colours fluxing softly on the pot they now stay as sharp or clean as I want to make them'.

He uses a base of all the primary colours, with a few extras; all are intermixable, so he can produce almost any colour, shade or tone that he wants, and they work very like oils or acrylics. This has led to Ross creating large areas within his designs that he treats as paintings in their own right. He paints with soft brushes, both watercolour and Japanese, which hold a lot of liquid but will form a good point; stiff brushes can scratch.

A scalpel is often used to define an area where sharp detail is needed. This area can be filled with colour, which will flow off the brush but stop exactly at the line.

Technical information

Clay Red earthenware clay with 10% sand

Slip Hyplas 71 with commercial stains, and copper carbonate for some greens. Nothing is measured.

Glaze **Transparent glaze**

Lead bisilicate	11
Borax frit	5
Hyplas 71 ball clay	4
Bentonite	1

Author's note: Bentonite is added to glazes to aid suspension and thus prevent the glaze from solidifying in the bottom of the bucket – 1% is the usual amount. Unless there is a high proportion of plastic clay in a glaze (such as a ball clay or a red earthenware clay), I *always* add bentonite.

Firing Biscuit firing is to 950°C (1742°F), glaze firing to 1132°C (2070°F) in one of two electric kilns. Ross used to fire to 1145°C (2093°F), but experienced problems with the slip/glaze layer shelling, especially with the 'snow-white' slip (50:50 zirconium with white slip) he uses on clock faces. Reducing the top temperature cured this problem.

Dylan Bowen (UK)

Dylan Bowen produces individual pieces in slipware; characteristically, both the making and the decoration are very loose. Dylan tries to capture the moment, a very Zen approach to the materials he uses.

Before attending Camberwell School of Art, Dylan worked for a couple of years with his father Clive at his pottery at Shebbear, North Devon. He says that Clive 'was always open to new ideas, new ways of working, and always very encouraging'. Following Camberwell he worked for various potters in the United States 'being a useless production thrower mainly'. After marrying Jane, also a slipware potter, they set up a workshop in Oxford where he made functional ware that sold locally. However, with the move to a new workshop in Tackley, 'things started to come together', ideas emerged, and Dylan felt he was beginning to find his own way of working with clay and slip.

Dylan cites his main influences on this journey as being music, slipware and abstract expressionism, although he adds 'but that's too small'. 'Ideas evolve in a slow and painful way, and simple ideas often seem to be the hardest ones to pin down' – and he stresses that 'you have to do the work, you have to get your hands on the clay, then things may start happening'.

Dylan has written, 'for me it is all about the moment', and this direct connection between artist and work is striking when viewing his pots. Although in retrospect he feels he took a long time to find his own direction, to discover what he wanted to do with clay, Dylan has developed a way to utilise traditional slipware techniques in an individual and highly contemporary manner.

Dylan Bowen slip trailing. PHOTOGRAPH BY BEN RAMOS.

Dylan Bowen decorating. PHOTOGRAPH BY BEN RAMOS.

Working methods

Dylan makes both thrown pots and slabbed pieces, mainly in red earthenware clay, which are slipped by dipping and pouring at the leatherhard stage. He likes to work fast on wet slip, and is 'attacking and bold' in his approach, with 'lots of pouring and squirting'. He uses a variety of trailers and brushes, sometimes laying the taller three-dimensional shapes flat to prevent the wet slip from sliding off. He looks for a fluid mark, but likes to be able to make out the specific idea – decoration that is overworked can easily become a mess.

Ideas for marks come from a variety of sources, including old slipware, paintings, photographs and graffiti. He is responsive to accidental events, which can lead to new directions – 'a mistake, an unplanned drip or loop, can lead down a new road'.

Technical information

Clay Valentine's standard red earthenware, plus the occasional use of grogged red clay, crank and sculpture clay.

Slips **White slip**
Peters Marland stoneware clay or Hyplas 71

Jane Bowen's black slip
Red clay	100
Iron oxide	21
Manganese dioxide	14

Blue slip
White slip	100
Cobalt oxide	3

Green slip
White slip	100
Copper carbonate	3

Glaze **Clear glaze**
Lead sesquisilicate	100
China clay	24
Flint	8

Honey glaze
Clear glaze with 1–3% iron oxide added

Firing Work is biscuit-fired to 960°C (1760°C) and glaze-fired to about 1075°C (1967°F) in a top-loading electric kiln. Some pieces are once-fired.

Plate by Dylan Bowen (d. 50 cm/20 in.). PHOTOGRAPH BY BEN RAMOS.

Françoise Dufayard
(FRANCE)

Françoise Dufayard is well-known to British potters and the pot-buying public alike – she has taken part in many shows, exhibitions and demonstrations in the UK, and has reciprocated by exhibiting British potters in her own studio in Rennes, Brittany. Her work, though essentially based on functionality, extends beyond this – massive 65 cm (25½ in.) square dishes resemble three-dimensional paintings with strong echoes of abstract art.

During the late 1980s Françoise studied at the Ateliers de Fontblanche in Vitrolles, and after travelling and working for several potters she set up her own studio in Rennes in 1988, where she makes a variety of work using slipware techniques; the French term is *terre vernisseé*. She developed her own range of earthenware slips without recipes from other potters. Her 'signature' is a black slip often used in a calligraphic way, and reminiscent, in its suggestion of infinity, of a Rothko painting.

She says 'When I paint a large-scale dish I become totally connected with the piece and work in an instinctive, creative way with the marks coming through me, but not from me. There is no possibility of changing or reworking a surface once it has been created'.

Working methods

Françoise uses slips in a variety of ways, techniques that combine to give depth to the surface of her work. After pouring, some areas may be given a coating of wax resist through which she later etches with a nail or a piece of wood to reveal the body clay beneath. The resulting line may then be coated with a contrasting slip and the excess removed from the wax, or it may be left as it is. She makes very expressive use of a variety

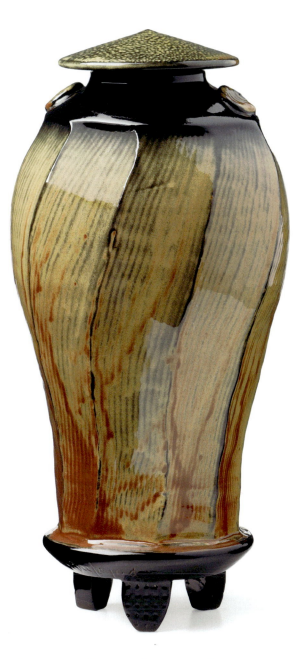

Pandora's Box by Françoise Dufayard (h. 35 cm/ 13¾ in.). PHOTOGRAPH BY HUBERT TAILLARD.

of paintbrushes, overlaying slip on slip with a large vocabulary of marks. Slip-trailed lines and even print from crumpled newspaper feature in her work.

Technical information

Clay PF from Collett/SIO-2, a Spanish clay sold through Ceradel in France. For larger pieces she uses PF/CHF, which contains 20% chamotte (grog).

Slips Françoise developed her own range of slips by experimentation.

Glaze PRO transparent glaze from Solargil in France.

Firing Françoise fires in a large gas-fired top-hat kiln for nine to ten hours to Orton cone 05 (1040°C/1904°F) for biscuit, and to Orton cone 02 (1110°C/2030°F) for glaze. She finds the high biscuit gives much better colours.

Françoise Dufayard in her studio painting slip over wax resist. PHOTOGRAPH BY HUBERT TAILLARD.

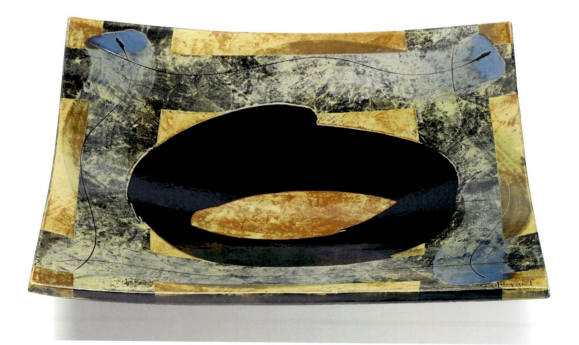

Landscape dish by Françoise Dufayard (65 x 65 cm/25½ x 25½ in.). PHOTOGRAPH BY HUBERT TAILLARD.

Ron Philbeck (USA)

Ron Philbeck lives in North Carolina. He originally wanted to be a sculptor, but was captivated by the world of ceramics and by the idea of making 'simple utilitarian pots for everyday use', and worked in salt glaze for more than a decade. However, Ron had been interested in earthenware for many years, but needed time to experiment with the materials. He also wanted to decorate more – most of his salt glaze had little embellishment – and in addition he had begun drawing again and wanted to apply this to his pots.

The first decorative technique he used was finger wiping, and he enjoyed the spontaneity and the simple patterns and figures this could produce. Later he tried sgraffito, he says unsuccessfully at first, though it is now the main technique he uses. He takes many of the subjects he draws onto his pots from the countryside in which he lives – goats, dogs, birds, chickens, flowers and trees – and he also incorporates domestic objects, such as irons, kitchen utensils, lamps, umbrellas, and furniture, all of which bring humour to the work.

Ron feels that function is still his main concern; he wants his pots to perform well, and to be fun and beautiful. 'I like when folks pick up a pot and give a little chuckle – I know they have connected with it.' And while acknowledging historical influences, he feels he is 'making pots of the present day, from the time and the place in which I live'.

Working methods

The pots are covered in white slip by pouring – he likes the uneven line wavering round the base of the pot – and sometimes dipping; often areas of bare clay are left to provide

contrast. Immediately after slipping, Ron will often make a finger-wipe line on the inside of cups and bowls. He does this 'to provide some decoration on the inside of the pot, and also just because I love to draw that simple wavy line with my finger'.

When the pot has returned to the leatherhard state Ron uses a looped wire tool (from Kemper Tools) to cut through the slip into the clay body, a method he likens to drawing with a pen. Mistakes cannot be rectified so there is a bit of risk involved in each piece. Drawings are planned in a sketchbook, to which Ron refers before he decorates.

Ron brushes slip onto some pots, as he likes the variations this gives. He also combs using a metal-toothed rib to create wavy lines, crosshatch patterns and short, quick parallel marks. When the pots are bone dry, any burrs of clay resulting from the incising are brushed away.

After biscuit firing, a black stain is occasionally brushed into the incised line,

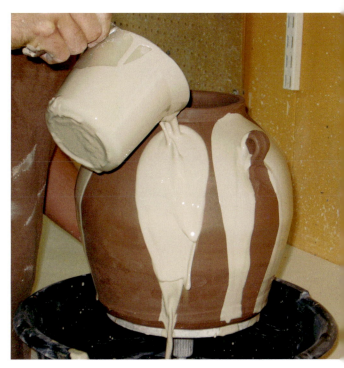

Ron Philbeck pouring slip onto a jar. PHOTOGRAPH BY SARAH N. PHILBECK.

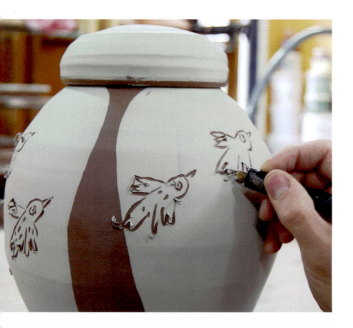

with the excess being wiped away with a sponge. This technique allows Ron to make the drawn lines darker.

Technical information

Clay	(cone 03 – 02, 1100°C/2012°F)	
	Red Art	40
	Lizella or Newman Red	20
	Hawthorn Bond	15
	Gold Art	15
	Wollastonite	5
	Silica (flint)	5
Slips	**Pete Pinnell's White Slip**	
	OM4 ball clay	40
	Talc	40
	Silica (flint)	10
	Nepheline syenite	10
	Zircopax	10–15%

Zircopax is a commercial brand of opacifier. Zircon (zirconium silicate) is listed in most pottery catalogues.

Slip for salt glaze

	EPK ball clay	80
	Nepheline syenite	20

Other types of china clay can be substituted for EPK with good results.

Black stain

	Ferro frit 3124	12
	Gertsley borate	48
	Black iron oxide	24
	Black copper oxide	14
	Cobalt oxide	2

Glaze	**Kari's Best Clear Glaze – cone 03**	
	Ferro frit 3289	25
	Ferro frit 3124	15
	Gertsley borate	15
	Spodumene	18
	Wollastonite	7
	EPK ball clay	20

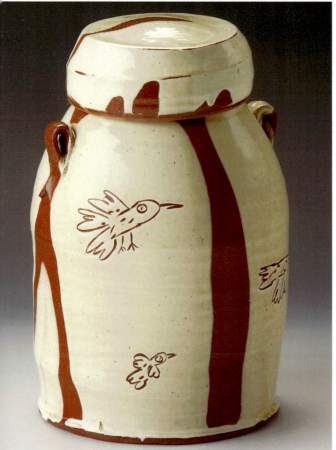

Top: Ron Philbeck drawing through slip.
PHOTOGRAPH BY SARAH N. PHILBECK.

Left: Bird Jar by Ron Philbeck (h. 24 cm/9½ in.).
PHOTOGRAPH BY RON PHILBECK.

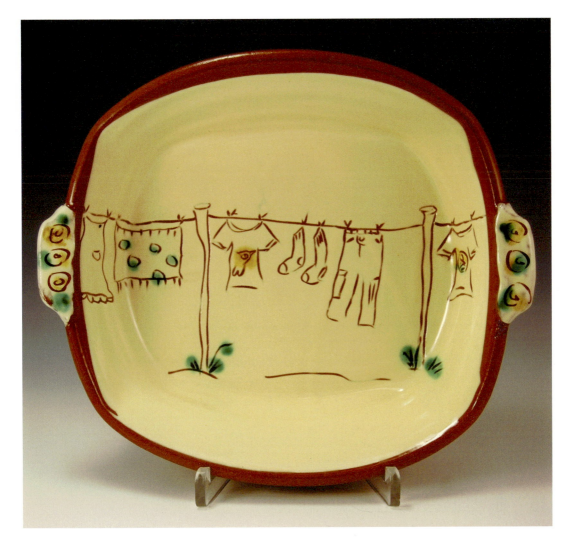

Gail Kendall's Amber – cone 03

Gertsley borate	35.52
Custer feldspar	34.58
Barium carbonate	13.08
Silica (flint)	10.28
Black iron oxide	6.54

Firing Work is biscuit-fired to cone 04 (1065°C/1949°F) and glaze fired to cone 03 (1090°C/1994°F) in an electric kiln. Glaze firings take around 12 hours, with a ten-minute soak. Ron points out that biscuit firing to cone 04 is common practice amongst the earthenware potters he knows.

'Washline' Baker by Ron Philbeck (max. 31 cm/12¼ in.). PHOTOGRAPH BY RON PHILBECK.

Graham Hudson (UK)

In the context of slip-decorated studio pottery, Graham Hudson's elegant and very contemporary work is unusual for two reasons – firstly, it is slipcast, and secondly, he uses semi-porcelain, a white firing body somewhere between white earthenware and porcelain.

Graham dates his interest in ceramics to finding a small Iron Age bowl whilst helping his father on an archaeological dig – the excitement of finding it, combined with its links to people and past cultures, left a lasting impression. During his first degree at Bath he became interested in slipcasting and its potential; he subsequently completed the MA in Ceramic Design at Staffordshire University, which involved an industrial placement at Denby Pottery. As many potters do, he now combines making with some teaching.

Graham's current work is tableware, both individual pieces and small-scale batch production. He writes, 'Use has always been a major inspiration in what I do. I try to keep my pieces simple, unfussy and contemporary, and my intention is for them to be visually appealing and a pleasure to handle and use.'

Graham regularly goes to the Ashmolean Museum in Oxford, each visit bringing new discoveries. These influences must be placed alongside that of his physical environment, an area of rolling downland marked by farming and ancient communities.

Working methods

Work is either slipcast or press-moulded, some with thrown additions, using a semi-porcelain body. The cast shapes are turned on the wheel, added to and altered. Graham then adds coloured slips, decorative surfaces and textures using a variety of techniques including wax resist and printing slips from sheets of newspaper, processes which allow him to give individuality to each piece of work.

Graham is constantly testing new glazes, slips, forms and patterns, with experiments in every firing. He writes, 'This is important and exciting and keeps my work moving and developing, creating something that I hope is unique to me. I do not see myself fitting into any genre, but rather as being a patchwork of many.'

Technical information

Clay	Potclays 1204M Semi-porcelain body	
Slips	**Red slip**	
	Potclays 1202 Red Terracotta casting slip	
	Black slip	
	Red casting slip	100
	Manganese dioxide	6
	Iron oxide	6
	Cobalt oxide	2
Glaze	Potclays 2205 Good Gloss glaze, opacified with 5% tin oxide or coloured with various oxides.	
Firing	After biscuit firing to 1040°C (1940°F), areas to be left unglazed are sanded to a silky finish, after which a white tin glaze is applied to the 'working' area of the pot. The final firing is to 1150°C (2100°F) with a 45-minute soak in an electric kiln.	

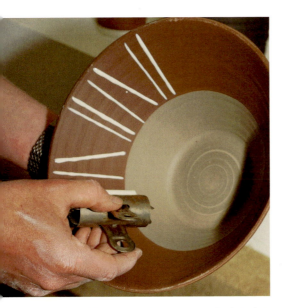

Graham Hudson printing wax on the interior of a bowl. PHOTOGRAPH BY JOHN MATHIESON.

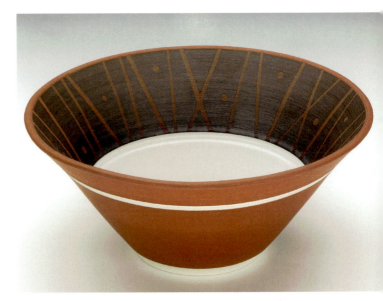

Bowl by Graham Hudson with interior design created using wax resist (d. 21 cm/8¼ in.). PHOTOGRAPH BY DAVID SMITH.

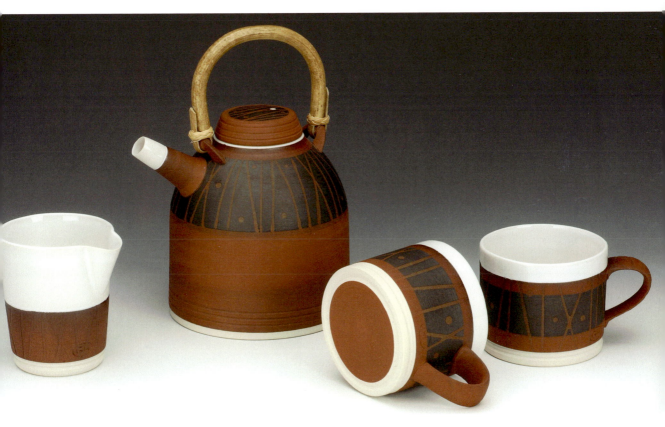

Teapot, jugs and mugs by Graham Hudson, (h. max 22 cm/8¾ in.). PHOTOGRAPH BY DAVID SMITH.

Douglas Fitch (UK)

Doug Fitch makes wood- and electric-fired slipware at Hollyford Pottery in the mid-Devon countryside. He says his pots are 'unashamedly traditional', and whilst this is true, they are part of a living tradition and very much Doug's own style. Often big and bold, with a rich lead glaze, they are wonderfully idiosyncratic.

Doug's earliest encounter with clay was finding shards in a ploughed field near the site of a medieval pottery at Lyveden, Northamptonshire. They fascinated him, but it was much later that their significance became apparent to him. He did his art foundation year at Kettering, and later completed the studio ceramics course at Derby College. However, the pivotal moment in his artistic development occurred on a visit to the Victoria and Albert Museum in London, where he saw a beautiful slipware jug that brought back memories of the field in Lyveden. 'Encountering this beautiful vessel was a life-changing experience that was to determine the direction of my remaining time as an undergraduate and my subsequent journey as a potter.'

Doug set up his own workshop and founded Hollyford Pottery in 2003. Many materials are sourced locally – his clay body is dug from woodland opposite his pottery, he is experimenting with slip clay from a nearby stream, and the glaze kiln is fired with salvage wood from a local sawmill.

Working methods

Doug likes to throw as directly as possible, without fuss, utilising the minimum number

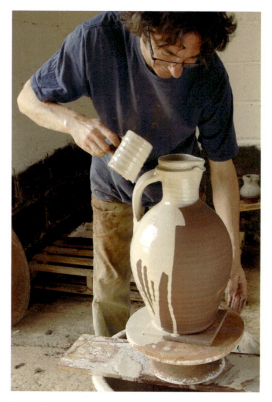

Doug Fitch pouring slip over a large jug.
PHOTOGRAPH BY JOHNNY THOMPSON.

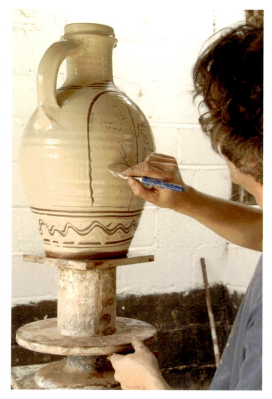

Doug Fitch drawing through slip on a large jug.
PHOTOGRAPH BY JOHNNY THOMPSON.

of moves, and leaving the marks of the maker's hands. He has a basic palette of white, green and black slips, which are used singly, and over and under each other, in varying thicknesses to give a wide range of tonal effects. The two galena glazes (used only on the outside of pots) give further variations.

'Potter's privilege' is the term Doug uses to describe the opportunity he has to see each phase of the slipware process, from gleaming wet, through a buttery sheen as the slip dries, to the matt surface of the touch-dry pot. Add to this the runs and dribbles (which Doug encourages – he likes to work with the slips still very wet) and his mark-making with comb, stick or finger; once started there is no turning back from this, no possibility of repair or correction – it needs confidence and fluidity. Timing is important – start the marks too soon and the slip can run and obscure them, too late and they look stilted and scratchy. Doug relishes the imperfections, in part as a reaction against the precision and standardisation of industrial wares.

To use the same materials as both his slipware contemporaries and the traditional potters who went before, and yet be an individual artist, is a challenge Doug acknowledges. He likens it to comparing blues singers – 'three simple chords and a solo vocalist, but Muddy Waters and Howlin' Wolf each possessed their own unique style'.

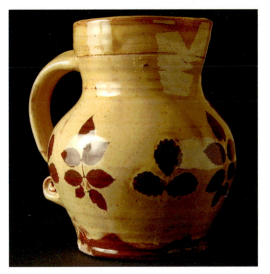

Right, from top: Doug Fitch sticking leaves on a jug for a leaf-resist pattern.

Doug Fitch peeling leaf resist from a slipped jug.

Leaf-resist jug by Doug Fitch.

ALL PHOTOGRAPHS BY JOHNNY THOMPSON.

85

Technical information

Clay Dug in the wood near the pottery, with sand added.
Occasionally Doug uses Valentine's clay mixed with Exeter brick clay for a coarse texture.

Slips **White slip**
Hyplas 71 ball clay

Black slip

Red clay	8
Manganese dioxide	2
Red iron oxide	2

Green slip

Hyplas 71 ball clay	100
copper oxide	5

Glazes **Yellow glaze** (outside only)

Galena	60
Hyplas 71 ball clay	30
Flint	10

Honey glaze (outside only)

Galena	60
Fremington clay	30
Flint	10

Inside glaze + any surface in contact with food:

Light yellow

Lead bisilicate	75
Hyplas 71 ball clay	25
Iron oxide	2

Dark yellow

Lead bisilicate	75
Fremington clay	25
Iron oxide	2

Firing Doug biscuit-fires to 900°C (1652°F) in an electric kiln, and glaze-fires in electric and wood-burning kilns; the latter has a temperature variation from Orton cone 05 (1040°C/1904°F) in the cool spots to Orton cone 03/02 (1100°C/2012°F) in the hotter parts.

Michael Eden (UK)

Michael Eden and his wife Victoria established their pottery in 1987 in Cumbria. Together they wrote *Slipware*, a review of contemporary approaches to the medium and an invaluable sourcebook for anyone interested in this art form. Victoria recently completed a ceramic installation entitled 'February 5th 2004', commemorating the deaths of 23 Chinese cockle pickers in Morecambe Bay.

Michael's work in ceramics has all been functionally related and has a distinctly contemporary look; the website uses the phrase, 'Bringing slipware into the 21st century', an honest statement reflecting the Edens' artistic vision and creative search.

Michael recently completed his master's degree at the Royal College of Art in London, where he explored the use of digital technology and new materials, including one with all the properties of slip, but which doesn't require firing!

Working methods

Work is thrown on the wheel and frequently altered; for instance, a 'dimple bowl' has depressions pressed into the clay to take individual apples, while the 'rocking bowl' (see photograph opposite, top) has been given a rounded base so that it will do as its name suggests. Some, such as the large square dishes, are made from slabs of clay. All work is decorated at the leatherhard stage with slips. After biscuit firing latex carpet adhesive is used to mask areas of the surface before the glaze is applied – significantly, large areas of many pots are left unglazed, with the contrast between the bright colours and the terracotta body lending an extra dynamic to each piece.

Technical information

Clay Valentine's 20% grogged earthenware and Scarva terracotta crank.

Slips **White slip**
Hyplas 71 ball clay

Coloured slips
Additions of 2.5% copper oxide for green, and 3.5% cobalt oxide for blue, or up to 15% body stains.

Black slip

Dry red clay	100
Red iron oxide	3.3
Manganese dioxide	2.2
Cobalt oxide	2.2

Vitreous slip

China clay	100
Ball clay	80
Potash feldspar	10
Zirconium silicate	10

This can be applied to biscuit ware, and stained in the same way as the white slip.

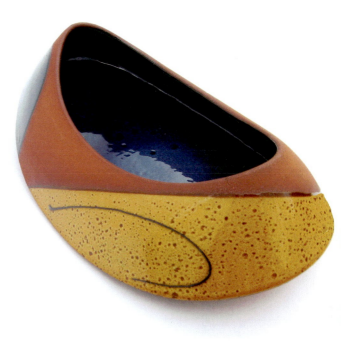

Rocking bowl by Michael Eden (l. 34 cm/13½ in.).
PHOTOGRAPH BY MICHAEL EDEN.

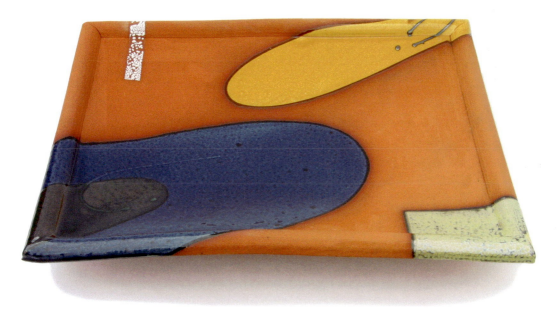

Square dish by Michael Eden (51 x 38 cm/20 x 15 in.). PHOTOGRAPH BY MICHAEL EDEN.

Glazes **Clear glaze 1**

Lead bisilicate	75
Cornish stone	20
China clay	10
Bentonite	10

Michael Eden says, 'very reliable and very tough' – an excellent raw glaze and very craze-resistant. Fired to 1105–1115°C (2021–2039°F).

Clear glaze 2

Lead sesquisilicate	100
China clay	24
Flint	8

Fired to 1075–1085°C (1967–1985°F).

Add 2% copper oxide for green, 1% cobalt oxide for blue, 4% iron oxide for orange, and for turquoise mix 25% each of the green and blue glazes with 50% clear.

Honey glaze

Lead sesquisilicate	3
Red clay	1

Fired to 1060–1080°F (1940–1976°F).

Firing Work is biscuit-fired in an electric kiln to 1020°C (1868°F) with a ten-minute soak. Although Michael does wood-fire some work, the pieces shown have been glaze-fired in an electric kiln.

Niek Hoogland
(The Netherlands)

'I've been interested in pottery and pot making as long as I can remember.'

Niek was brought up in Tegelen, where clay has been used since at least Roman times; the Roman name Tegula means roof tile. Niek's father worked in one of the local factories and often took Niek with him, where he would find a quiet corner and play with clay. A neighbour was a potter, and as a five-year-old child Niek would go to his pottery just to watch him work. When he left school at the end of the 1960s Niek wanted to become a potter, but most potteries had shut down due to lack of demand so this was not possible. He became a nurse, working with mentally disabled people, and it was there that he met his wife, Pim van Huisseling.

Niek later had the opportunity to train with a local slipware potter, Theo van Rens. The approach was very traditional – Niek comments, 'If you look only at tradition you are on a path that becomes narrower at every step.' His research led him to realise 'that what we think of as typical for a specific region is often the sum of local tradition, plus an outside influence, combined with the particular handwriting of the potter picking up new influences to incorporate in his own work'.

Niek then became apprenticed to Joop Crompvoets from Pottenbakkerij De Walsberg where 'it all came together'. Following this training, Niek worked as a repetition thrower in Beesel ('boring and tedious but a very good way to become a potter'), and then with his wife set up his own pottery with a borrowed wheel and a second-hand electric kiln.

From the start Niek knew he wanted to make slipware – he had trained in slipware, the slipware tradition in his area was not

completely dead, and it was slipware that appealed to him most. He wanted to use this background to find a way to make contemporary ceramics.

Niek enjoys making pots that can be used – bowls, casserole dishes, teacups and teapots, creamers and jugs, cutlery drainers and colanders. He also makes tiles, both individually and as whole panels, and commemorative pieces for births, weddings and anniversaries.

Working methods

Most of Niek's work is thrown on an electric wheel, or slabbed using an electric-powered slab roller. He uses red earthenware clay from Westerwald, to which sand or grog is added and mixed in an old dough-mixer. The clay is pugged through a de-airing pugmill and stored before use. Occasionally Niek uses a 'very crude clay' from a local clay pit.

Niek likes to work as directly as possible, making a small series of a particular shape or type of pot. He weighs the clay, but does not set height or width gauges. 'While I'm throwing I like to consider each pot of that series as an individual piece. I like to finish a pot on the wheel as much as possible, so I have to do very little or no trimming later. Marks of the making and handling of the pot are not over emphasised, nor are they polished away.'

When the pots are leatherhard, Niek adds the handles and performs any necessary trimming. Slipping is done at this stage too,

Right & overleaf: Jug decorating sequence by Niek Hoogland. ALL PHOTOGRAPHS BY PIM VAN HUISSELING.

1 Niek Hoogland pouring slip over a jug.

2 Three freshly slipped jugs.

3 Sgraffito through leatherhard slip.

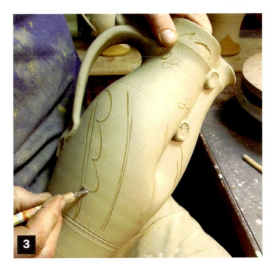

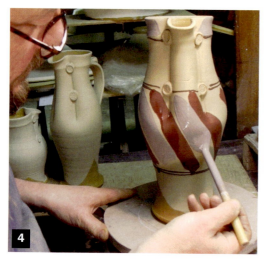

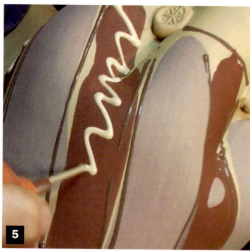

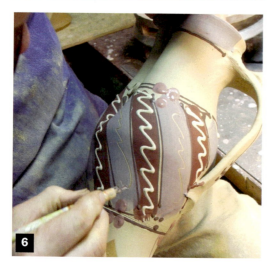

4 Painting slip onto the jug.

5 Slip-trailing onto jug.

6 Sgraffito through painted slip.

by pouring firstly the inside and when the pot has dried back to leatherhard, the outside. Runs and overlaps, as well as thicker and thinner areas all add interest. Sgraffito decoration is done while the pot is still moist. Niek says he used to do a lot of sgraffito on bone-dry pots, but decided to rethink his techniques because of the dust hazard.

Slip trailing and painting is usually done on the bone-dry pots. He uses 'all sorts' of brushes to paint a watery-coloured slip that can be outlined with a slip trailer; sometimes details are scratched into the coloured areas.

Recently Niek has been focusing on raw glazing, which forces him to work more directly – 'I have to stick with the whole process of making, decorating, drying and firing in one sort of flow. I like to think the pot becomes more of a whole that way.'

Technical information

Clay	Red earthenware from Westerwald with added grog or sand.
Slips	**White slip**

Westerwald clay (a medium plastic, white-firing stoneware clay from German Westerwald) 7
Quartz 2
Whiting 1
The base for most slips.

White slip (for tiles)
Hyplas 71

Blue slip
White slip plus 2% cobalt oxide.

Green slip
White slip plus 4% copper oxide.

Red-brown slip

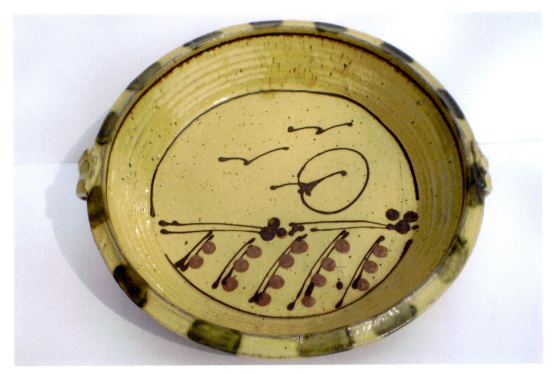

Large dish by Niek Hoogland, made from local clay with brushed and trailed slips, (d.43 cm/17 in.). PHOTOGRAPH BY NIEK HOOGLAND.

White slip plus 8% iron oxide.

Black-brown slip

White slip plus 5% iron oxide and 10% manganese dioxide.

Yellow slip

'Brunsummer clay', a natural clay from Limburg.

Yellow-brown slip (only used for painting)

Iron oxide	1
Manganese dioxide	1
Rutile	1
Westerwald clay	3

Glazes Niek prefers to add red clay rather than iron oxide to his glazes. 'Iron oxide stays a bit cloudy in the glaze, giving darker and lighter spots on the work. Red clay gets very evenly dispersed in a glaze and gives the warm honey shine that I like in slipware.'

For biscuit ware

Lead bisilicate	600
Borax frit	100
White Westerwald clay	150
Red earthenware clay	150

For raw glazing (single firing)

Lead bisilicate	700
Potash feldspar	125
Red earthenware clay	63
White Westerwald clay	95
Bentonite	95

Both glazes fired to 1100°C (2012°F). Seger cone 1a.

Firing The work is fired in either an electric or a gas kiln. Biscuit firing is to 900°C (1652°F). Niek finds firing with gas makes the clay a little darker and the glaze less brilliant, and it some-times gives the coloured slips a metallic sheen.

John Pollex (UK)

An important figure on the British pottery scene since the early 1970s, John Pollex initially established a reputation for traditional slipware, but later changed to producing highly individual colourful work strongly influenced by abstract art.

John studied at Sir John Cass College in Whitechapel, London, and then became a technician on the highly influential ceramics course at Harrow College of Art from 1968–1970. The tutors included Mick Casson, Victor Margrie and Colin Pearson. Later, in 1971, following a period as assistant to Colin Pearson, he moved to Plymouth where he still lives. There he set up a workshop producing a wide range of slipware with a rich honey glaze, from domestic ware to harvest jugs and over 500 huge chargers, each of which took a day to

Teapot by John Pollex, (h. 13 cm/5 in.).
PHOTOGRAPH BY JOHN POLLEX.

decorate. His book *Slipware* (see Bibliography) was highly influential.

After some 14 years working in this way John was becoming increasingly dissatisfied – he felt that he had explored all the techniques for decorating slipware, and the work was no longer challenging or stimulating to him. Sometime during the 1970s he had seen brightly coloured pots by Betty Woodman and Andrea Gill in an exhibition in Brussels, marking the beginning of his fascination with American ceramics. Of even greater importance was his meeting with the American potter Don Reitz in New Zealand. John was awestruck by the way Don worked, an influence that remains to this day. His use of colour, spontaneous and bold, was in strong contrast to the subdued palette popular in the UK at that time.

These experiences led to John dramatically changing his working methods in 1984. He mixed a number of colours, bought some brushes, abandoned the slip-trailer and took the iron oxide out of his glaze (without iron oxide the glaze becomes colourless and loses the modifying effect of the honey colour over the slips). After six months of experimentation he exhibited a new body of work, to a positive response. The pieces were decorated with abstract patterns using brightly coloured slips applied in a painterly manner under a colourless transparent glaze. Even if the pot was functional in form, its shape was often distorted.

John cites the paintings of Howard Hodgkin, Robert Natkin, Patrick Heron and Ben Nicholson as major influences. His long-standing interest in Zen Buddhism and calligraphy is also referenced in his decoration.

Working methods

John make pots on the wheel, and a number of flatter shapes – square dishes and forms he calls 'screens' – from slabs of clay.

When decorating, all colours are applied to a black background slip; this gives depth to the colour should they burn out slightly in the glaze firing. The black slip is poured and dipped for hollowware, and brushed onto flatware, when the works are leatherhard.

John may plot an image onto the black background slip with a brush dipped in water, or begin by making marks with sponges. Colours are added using a variety of brushes, and the decoration may be finished by applying slip with strips of thin plastic cut from the tops of yoghurt pots, giving a mark similar to that of a spatula used with oil paint.

Technical information

Clay White earthenware

Slips **Black background slip**

Red clay	68
Red iron oxide	13.2
Potash feldspar	9.5
China clay	4.75
Manganese dioxide	4.75

Sieved through a 120s mesh twice.

White base slip for colours
Throwing clay crushed to a powder before adding water – sieved through a 120s mesh twice.

Preparation of coloured slips
To make the coloured slips, 20 g ($^3/_4$ oz) of body stain is mixed with about 1 cm ($^3/_8$ in.) of water in a 450 g (1 lb) yoghurt pot. The white base slip is added to this and mixed to a thin creamy consistency.

John also mixes neat solutions of body stains in plastic film canisters. These can be added to small quantities of slip to create a wide range of colours.

Firing Work is biscuit-fired to 1050°C (1922°F) and glaze-fired to 1115°C (2039°F) in an electric kiln.

Jug by John Pollex (h. 22 cm/8¾ in.).
PHOTOGRAPH BY JOHN POLLEX.

Clive Bowen (UK)

Clive Bowen is one of the leading potters of his generation. He makes a wide range of slip-decorated domestic ware and individual pieces which are once-fired in a wood-burning down-draught kiln.

Seeing Clive's pots at his Goldmark Gallery exhibition was a remarkable experience. More than 200 pieces were on display, all but one of which had come from the kiln less than two weeks before the opening. These pots, in addition to being a remarkable artistic achievement, were a celebration of life, a glowing affirmation of vitality. The monograph published by the gallery in conjunction with the exhibition is an essential reference for anyone interested in slipware.

Like so many potters, Clive discovered clay by accident. He had trained as a painter at art school in Cardiff, but it was throwing pots at Michael Leach's pottery that brought him into ceramics. After an apprenticeship with Leach, he worked for a short time as a thrower at Brannams of Barnstaple, and

Tall jugs by Clive Bowen. PHOTOGRAPH BY JAY GOLDMARK/GOLDMARK ART.

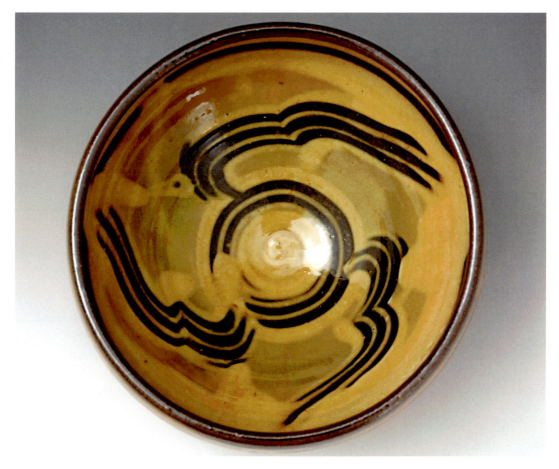

Bowl with combed decoration by Clive Bowen. PHOTOGRAPH BY JAY GOLDMARK/GOLDMARK ART.

helped Michael Cardew with firings at Wenford Bridge. Cardew had strong links with the Devon slipware tradition, and had made wonderful slipware himself at Winchcombe Pottery (John Edgeler's beautifully illustrated books provide more information – see Bibliography).

Clive established his own workshop in Shebbear, north Devon in 1971. He uses a limited range of materials, which he has explored in depth. The local Fremington clay gives the work a unique character, while the combination of very few glazes and several different slips with the wood-firing give the finished pieces qualities unattainable in any other way. The work is neither stamped nor signed but is totally unique, and obviously from Clive Bowen. His pots are almost all functional; to me they are the result of an effortless, unconscious fluency that allows the materials to sing, with decoration reminiscent of abstract expressionist art.

Working methods

Most work is thrown, with smaller pots being made on a Leach kickwheel, and larger ones on a Soldner electric wheel, which will take 90 kg (200 lb) of clay and turn as slowly as is required. Some pieces are press-moulded.

Pots are slipped at the leatherhard stage by pouring, dipping, brushing and trailing. The trailing can be vigorous – to do the lines

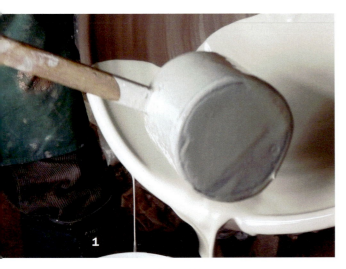

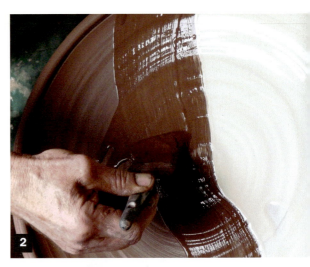

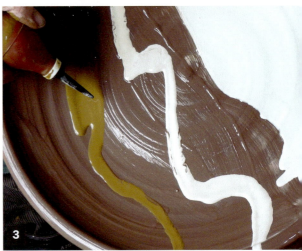

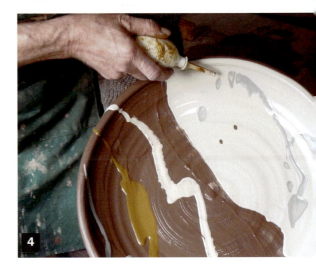

Clive Bowen decorating sequence.
PHOTOGRAPHS BY ROSIE BOWEN.

1 Clive Bowen pouring slip into a large bowl.

2 Painting black slip onto the bowl.

3 Trailing further colours on top of the black.

4 Squirting slip onto the white layer.

on the outside of his big pots Clive squirts the slip upwards. Sgraffito is done through wet slip with a wooden tool or rubber comb. Sometimes chatter decoration, learned from visiting potters from Onda in Japan who have worked at the pottery, is used (see photograph, p.21). The decoration is loose, and the pots are not regarded as precious. With the exception of some pieces, which dry out too quickly in summer and are biscuit-fired in an electric kiln, everything is glazed when leatherhard then once-fired.

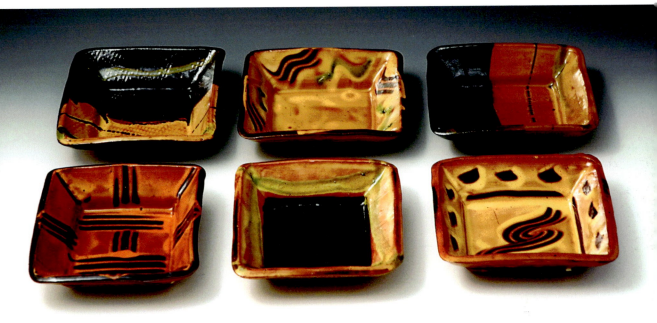

Square press-moulded dishes by Clive Bowen. PHOTOGRAPH BY JAY GOLDMARK/GOLDMARK ART.

Technical information

Clay Fremington red clay from north Devon.

Slips **White slip**
Peters Marland stoneware clay

Red slip
From a nearby stream bed.

Black slip

Fremington red clay	8
Iron oxide	1
Manganese dioxide	1

Green slip
Peters Marland clay + 3% copper oxide.

Glazes **Clear glaze**

Galena	60
Ball clay	30
Flint	10

Note: This glaze must only be used on the outside of pots.

Yellow glaze

Lead bisilicate	72
Clay	28
Iron oxide	750
Bentonite	1

Dark honey glaze

Lead bisilicate	72
Clay	28
Iron oxide	4
Bentonite	1

Clive used to add 3 parts of flint to both the yellow and the dark honey glazes, but has recently stopped doing so.

Firing Pots are once-fired with wood in a 2.5 m (8 ft) diameter down-draught wood-burning kiln to 1040–1060°C (1904– 1940°F).

97

Paul Young (UK)

Paul Young makes a wide range of sumptuously decorated individual pieces and domestic ware in both thrown and handbuilt slipware.

A Victorian building on the platform of the old station at Shenton in Leicestershire has been Paul's workshop for some ten years. His interest in slipware began at college with a series of lectures given by Geoffrey Fuller; the influence of his subsequent research into medieval and later ceramics can be seen in the chargers, baking dishes, jugs and pew figures he makes.

However, Paul's work, while stemming from this blend of traditions, is both very individual and highly accomplished, and his range of skills extraordinary. I have watched him unpack a series of stunning chargers delivered for an exhibition (at The Long Room Gallery, Winchcombe), each with masterly decoration, a long slip-trailed curve outlining a bird for example. Three-dimensional figures, including mermaids, sitting or standing on a press-moulded base with trees and many other features, display his modelling abilities and attention to detail. There are elaborately decorated boxes with creatures perched on the roof lids, thrown candlesticks with decorative additions, dovecotes, wassail pots, and domestic ware – jugs, bowls, storage jars – all made with the same loving care.

Paul exhibits and demonstrates both in the UK and abroad, including recently in India, and his work is in many national and international collections.

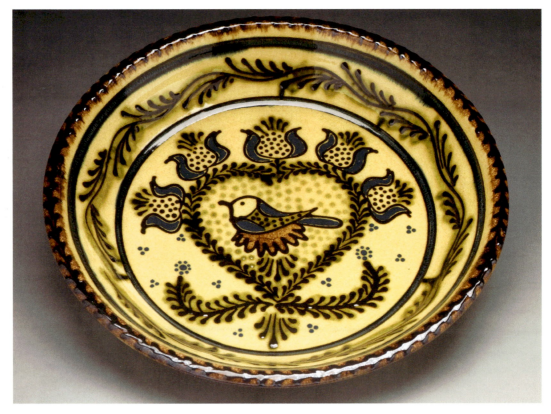

Platter by Paul Young (d. 42 cm/16½ in.). PHOTOGRAPH BY PETER TAYLOR.

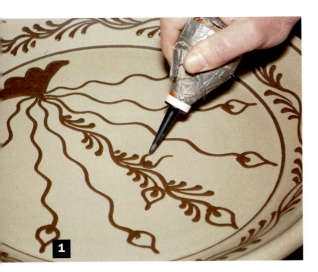

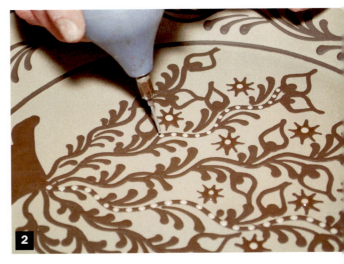

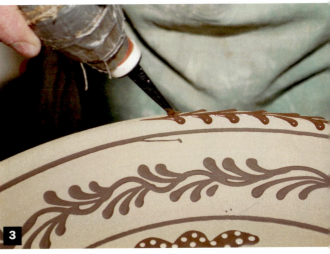

Paul Young, decorating sequence. PHOTOGRAPHS BY JOHN MATHIESON.

1 Paul Young slip-trailing a large dish.

2 Adding white dots of slip.

3 Slip trailing along the edge of the dish.

4 The completed dish by Paul Young.

Working methods

Paul throws on a big momentum wheel which he built himself. Thrown work is mainly decorated with a favourite and much-patched slip trailer directly onto the clay body – there is usually no background slip, though occasionally a contrasting slip is lightly sponged onto a platter. On more complex pieces Paul adds modelled decoration, often including many small leaves, and birds are also frequently featured.

Figure groups, mermaids and trees are individually modelled onto press-moulded bases. Boxes are built from hand-rolled slabs. These are textured before cutting and assembling using an Indian printing block found at an antiques fair, which is hammered onto the flat clay. Corn flour, which burns away in the biscuit firing, is sprinkled on the clay to prevent sticking. Very careful drying is essential to avoid warping.

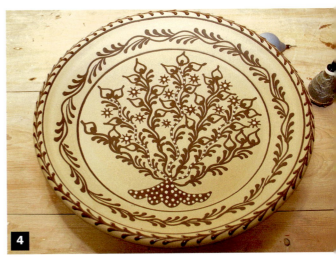

Candlestick by Paul Young (h. 25 cm/10 in.). PHOTOGRAPH BY PETER TAYLOR.

Technical information

Clay **White body**
Equal parts of Valentine's Grogged White and Earthstone ES20, which gives 'a great colour response'.

Red body
Valentine's 20% grog

Slips **White**
Throwing slops

Green
Throwing slops + 3% copper oxide.

Blue
Throwing slops + 1–3% cobalt oxide.

Black
Red clay + manganese dioxide – not measured, but mixed 'until it looks right'.

Glaze **Light honey glaze**

Lead bisilicate	8
Red clay	1
Potash feldspar	1

Firing Work on white clay is biscuit-fired to 1100°C (2012°F), and glazed at 1120°C (2048°F) in an electric kiln.

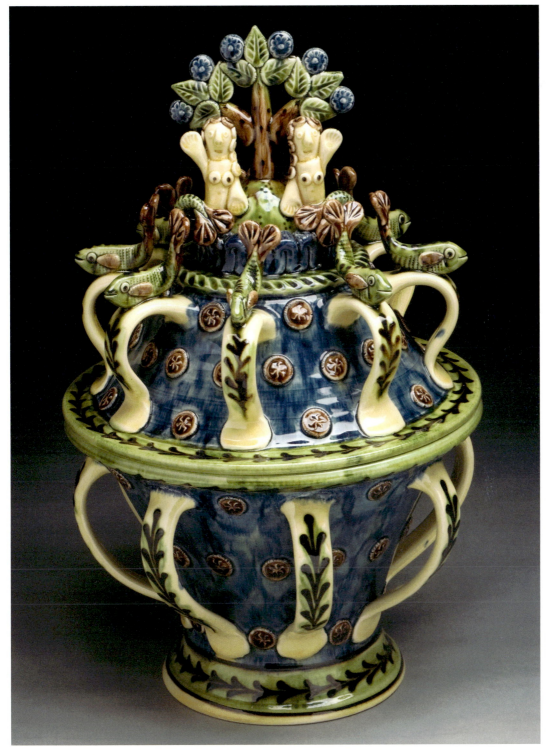

Wassail pot by Paul Young (h. 45 cm/17¾ in.). PHOTOGRAPH BY PETER TAYLOR.

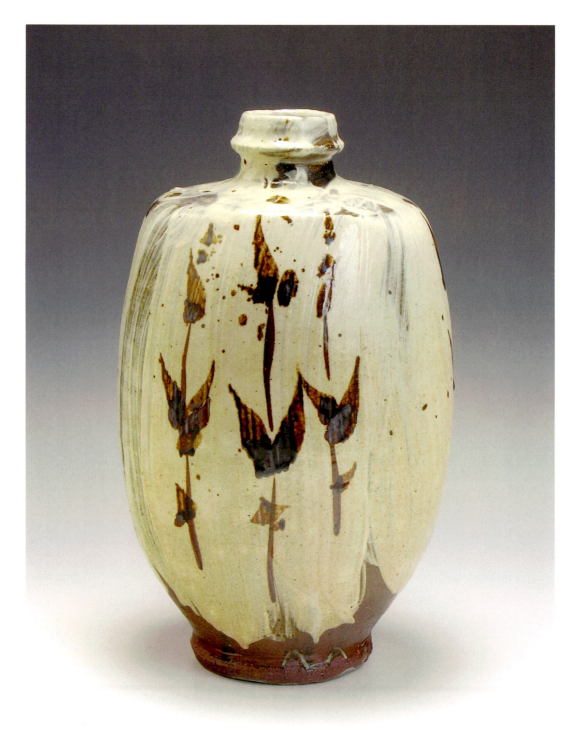

Bottle by Jim Malone. Following turning, the pot was given an iron wash, after which it was brushed with white slip. After biscuit firing the pattern was painted with pigments over the glaze, (h. 21 cm/ 8¼ in.). PHOTOGRAPH BY DAVID BINCH/OAKWOOD CERAMICS.

8 Slips with Stoneware and Porcelain

Pots fired above 1200°C (2192°F) are normally regarded as stoneware. At this temperature clay, slip and glaze fuse together more than with earthenware, creating a stronger bond with greater interaction between the different layers (microscopic sections show the integration of these layers clearly). There is a strong far-eastern influence to be found in the work of some potters in this section, for example Jim Malone, reflecting the impact of Bernard Leach's writings on British and American ceramics. Others, such as Fritz Rossmann, have a more European approach. Yo Thom is influenced both by her Japanese heritage, and by the function her pots will perform, while landscape is the dominant factor affecting Megan Collins's work.

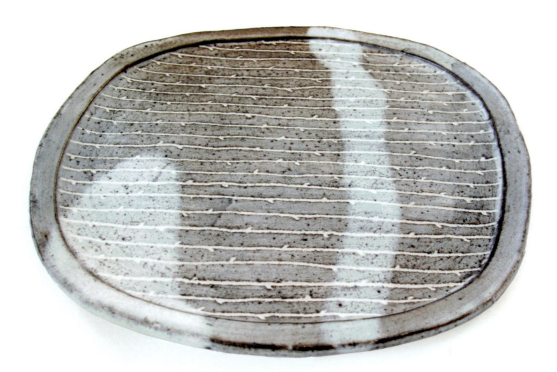

Plate by Yo Thom, Ai (Indigo) range, indigo slip under matt white tin glaze, (max 34 cm/13½ in.).
PHOTOGRAPH BY YO THOM.

Yo Thom (JAPAN/UK)

With the combined influences of both her Japanese background and her British training in ceramics, Yo Thom makes unique thrown and handbuilt functional stoneware.

Yo came to the UK after completing a degree in English at Dokkyo University in Japan and enrolled in the HND Three – Dimensional Design course at Kent Institute of Art and Design. She later transferred to the BA course at the Kent Institute, and subsequently took an MA at the same college. During her MA course, in order to improve her throwing technique Yo started assisting Lisa Hammond in her Maze Hill Pottery, where 'the honesty and humanity of the pottery life inspired me immensely'. The main production at Maze Hill is soda-glazed kitchen and tablewares, with a strong Japanese influence. Following graduation Yo became a full-time apprentice to Lisa, before eventually setting up her own pottery in Hackney, London.

In her student years Yo found British ceramics to be much more open and expressive than Japanese, where pottery is steeped in a tradition that can be very conservative. However, the idea of producing her own tableware gradually brought her back to her origins, 'Being away from my own culture made me think and realise that Japanese pottery, especially functional pottery, actually has a very unique quality'. She now produces a range of both handbuilt and thrown functional tableware in stoneware with 'influence from both British and Japanese traditional pottery and food culture' which, quoting Rosanjin* from *Uncommon Clay, The Life and Pottery of Rosanjin,* she hopes will become 'clothes for food'.

*Rosanjin Kitaoji (1883–1959) – 'a Japanese potter and restaurateur who is one of the most influential figures to many Japanese functional potters today'. See also the Bibliography.

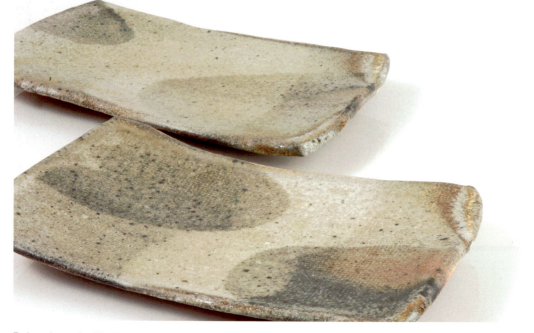

Boku plates by Yo Thom, red iron slip under shino glaze, (max 20 cm/8 in.). PHOTOGRAPH BY WILL THOM.

Working methods

Boku range

Earlier in her career Yo worked extensively with a simple shino glaze, which can give great variation, from hard white to soft pinks and dark reds, depending upon the type of clay used, the glaze thickness and the type of firing. I use one of Yo's shino coffee mugs every day. After translating for Ken Matsuzaki at a workshop in the UK, Yo was inspired to use red iron slip under the shino glaze, but found the decoration too vivid and the glaze lacking in depth when fired in a gas kiln. Later she had the opportunity to wood-fire some of these pieces, and they responded well to the fly ash and flashing, with the colour more subdued and the decoration only partially coming through the glaze. Since then she has decorated with the intention that it should be somewhat hidden – she quotes a Japanese saying: 'A full moon is beautiful, but even more beautiful when it is partially hidden with clouds.'

Yo has found a good source of iron-rich clay at the kiln site in Surrey, to which she adds a little iron oxide for the slip. She draws patterns and motifs with a brush, and adds sgraffito lines; she wants the iron-slip drawings to come out as dark shadows under the glaze.

She biscuit-fires the slipped pots to only 800°C (1472°F), and applies the shino glaze by pouring, not dipping. The very porous biscuit-ware allows pinholes and fine cracks to develop in the glaze surface.

Right, from top: Yo Thom making a window with slip on Boku ware. PHOTOGRAPH BY WILL THOM.

Yo Thom drawing Japanese pampas grass inside the window. PHOTOGRAPH BY WILL THOM.

Chawan (tea bowl) by Yo Thom, with bamboo fence pattern, red iron slip under shino glaze, (d. 11 cm/4¼ in.). PHOTOGRAPH BY WILL THOM.

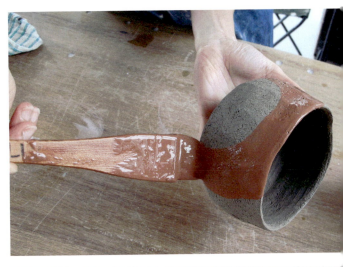

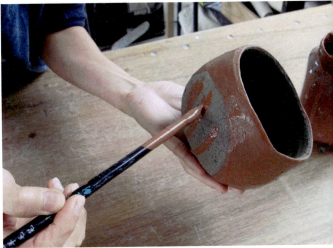

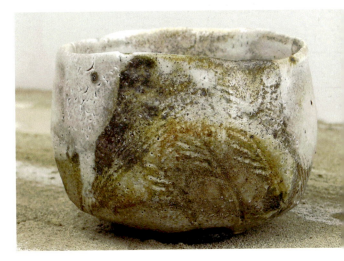

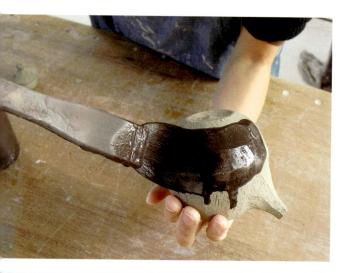

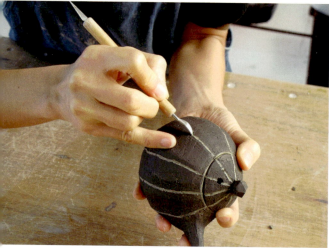

Ai (indigo) range

When first using her electric kiln Yo, looking for a way to give depth to the surface, made numerous experiments with different slips. She eventually decided upon a combination of indigo slip under a matt-white tin glaze, which gives 'imperfect tones of blue-grey-brown' when fired. She doesn't stir or grind the mix, but simply puts everything in a bottle and gives it a good shake!

The slip is brushed onto the leatherhard pots and allowed to dry a little before sgraffito lines and dots are added. After biscuit firing to 950–1000°C (1742–1832°F) the white glaze is applied. This will sit in the sgraffito lines and dots to give a blue-grey background with white patterns.

Left, from top: Yo Thom painting slip on a soy sauce bottle, Ai(Indigo) range. PHOTOGRAPH BY WILL THOM.

Yo Thom scoring lines through slip, Ai (Indigo) range. PHOTOGRAPH BY WILL THOM.

Two soy sauce bottles by Yo Thom, Ai (Indigo) range, indigo slip under matt white tin glaze, (h. 9 cm/3½ in.). PHOTOGRAPH BY WILL THOM.

Below: Pinched bowls by Yo Thom (max. 8 cm/13¼ in. diameter), Ai (Indigo) range, indigo slip under matt white tin glaze. PHOTOGRAPH BY YO THOM.

Technical information
Boku range (wood-fired shino)

Clay Potclays Original Raku

Slip Local earthenware clay from the kiln site in Surrey with 5% red iron oxide added.

Glaze Potash feldspar 75
HVAR ball clay 25

Firing Wood-fired to 1280°C (2336°F) in reduction.

Ai (Indigo) range

Clay Earthstone Original and Potclays Original Raku in equal parts

Slip China clay 20
Cobalt oxide 20
Manganese dioxide 10
Nickel oxide 10
Red iron oxide 5

Glaze Potash feldspar 49.5
China clay 24.7
Dolomite 21.7
Tin oxide 3
Bone ash 2.1
Whiting 2.1

For inside mugs and Ai (Indigo) soy bottles
Potash feldspar 70
China clay 13
Dolomite 5
Zinc oxide 5
Whiting 4
Quartz 3
Tin oxide 2

Firing Fired to 1250°C (2282°F) in an electric kiln.

Jim Malone (UK)

Jim Malone has an international reputation for his work in reduced stoneware in what has become known as the 'Leach tradition' – the synthesising of Oriental and English influences.

Jim initially trained as an art teacher, and after moving to London taught in a secondary school in Essex. He was accepted to study art at Camberwell, and as part of the foundation course had to take a 3D craft; he opted for ceramics, where Ian Godfrey was a tutor. Ian took Jim to the Victoria and Albert Museum, where he was deeply impressed with early Korean pots, an event which marked his conversion to ceramics. He studied Chinese, Korean and medieval English pots in the London museums, and spent two months working with Ray Finch at Winchcombe Pottery during one summer vacation.

After graduating Jim set up his first pottery near Llandegla, North Wales, later moving to Cumbria. His most recent exhibition was at the Goldmark Gallery, Uppingham where he showed 180 pots. His work includes unomis, tea bowls, jugs, storage jars, pilgrim bottles, teapots, large bowls, slab-built bottles and massive thrown bottles.

Regarding his deep commitment and dedication to pottery, Jim has said 'I am not affected by current 'trends' and I avoid gimmicks. I have never felt the need to spread myself any wider, only to delve deeper'.

Working methods
Most of Jim's work is thrown on a Korean-type momentum wheel, with some bottles being press-moulded. Pots are treated to a wide variety of decorative techniques both in the raw state and after biscuiting, which include slips, incising, ridges, stamps, paddling, small indentations and added pellets.

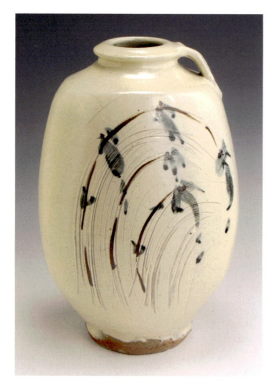

Vase with handle by Jim Malone, (h. 19 cm/ 7½ in.). After turning, the pot was flattened on two sides. It was then dipped in white slip, and a coarse brush was dragged through this while the slip was still wet, giving a feeling of movement over which to paint the pattern. The pattern was painted with pigments over the glaze after biscuit firing. PHOTOGRAPH BY DAVID BINCH/OAKWOOD CERAMICS.

Jim uses slips in different ways to provide a background for his onglaze brushwork. The white slip may be brushed directly on to the pot, giving a textured surface known as hakeme; it may be brushed over an iron wash or an ochre slip; or the pot may be dipped in the slip to give an even covering, which may then be textured to add movement to the onglaze painting. He has a number of different brushes, some homemade, but his favourite is a 'big floppy one which started out life as a Scottish hearth brush'.

After the biscuit firing and glazing, the patterns are brushed onto the glaze using iron and cobalt pigments. 'This means you just get one shot at it, and forces me to approach it in a spontaneous and direct manner, without becoming too precious or fiddly.'

Jim employs a fairly small range of glazes which, used under and over each other, and in conjunction with slips, give a wide variety of effects; he explores fully the potential of all the materials he uses, testing the variables through up to three firings before finally committing them to a body of work.

Wherever possible Jim likes to use locally sourced materials for his slips and glazes; living in Cumbria, with its exposed geology, helps in finding materials – for instance, a new source of river iron.

Technical information

Clay	From W.J. Doble Pottery Clays, St. Agnes, Cornwall, with additions of fireclay and sand.	
Slips	**White slip 1**	
	White ball clay	60
	China clay	40
	White slip 2	
	Hyplas 71	2
	Molochite	1
Glaze	Cornish stone	52
	Ball clay	23
	Ash	12.5
	Talc	5
	China clay	5
	Whiting	2.5
Firing	Jim biscuit-fires to 930°C (1706°F) in a 20 cu. ft electric kiln. Glaze firing is to 1260–1300°C (2300–2372°F) in his two-chambered oil- and wood-fired climbing kiln. The firing takes 24 hours, after which the kiln is rapidly cooled to 1000°C (1832°F), when it is clamped up and allowed to cool slowly for five days, whereupon it is ready for unpacking.	

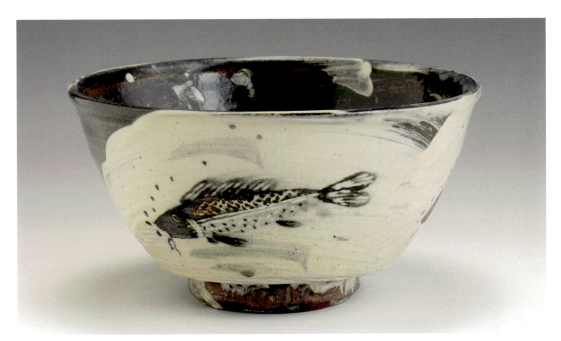

Fish bowl by Jim Malone (h. 9 cm/3½ in.). Panels of white slip are brushed over ochre slip to provide a background for the fish. After biscuit-firing, pigments were painted over the glaze and details of the fish drawn into this with a sharp wooden tool. PHOTOGRAPH BY DAVID BINCH/OAKWOOD CERAMICS.

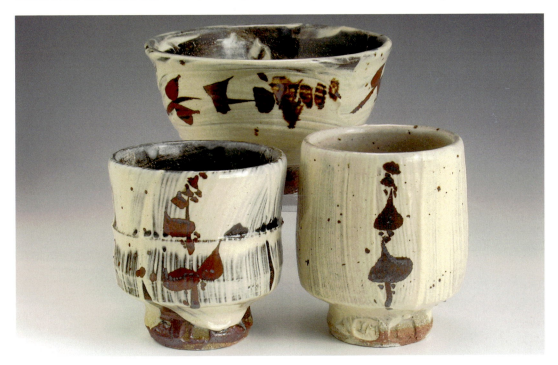

Yunomi group by Jim Malone (h. 9.5 cm/3¾ in. max.). Onglaze brushwork over Hakeme slip. PHOTOGRAPH BY DAVID BINCH/OAKWOOD CERAMICS.

Motoko Wakana
(Japan/UK)

With a Japanese sensibility and strong English overtones Motoko's work combines both influences in a highly original way.

Motoko taught art in a secondary school in Japan for five years, and during this time developed a strong interest in craft, in 'making something to use'. She took an intensive two-year course in ceramics at art college and after graduating she moved to Kanazawa to train and work – Kanazawa, a historic city, is called *Small Kyoto*, with many traditional crafts being practised there. Motoko travelled to Britain in 1999, and through her reading was attracted to British slipware. She worked with Mary Wondrausch for a short time, later staying with Clive and Rosie Bowen for two months. She was very impressed with their country lifestyle – from the making and firing of pots using local materials, to the growing of food, and also their generosity and hard work.

John Bedding, who runs the St Ives Gallery, saw Motoko's work at Clive's pottery; through him she worked in St Ives at the Gaolyard Studios for more than five years, and exhibited widely in the UK. Subsequently Motoko visited potteries in Korea and her homeland; having been out of Japan for over six years she was able to reassess her attitude towards her own country's ceramics. She now teaches in Tokyo and makes pots, both inlaid/slip-trailed and enamelled Kutani ware.

Working methods

Motoko works mainly on the wheel, with some pieces being press-moulded. When the pieces have stiffened slightly (and before turning in the case of thrown pots), Motoko carves and impresses marks into the clay – circles are done on the wheel, others by using stamps or by scratching. Slip is brushed into these indentations; when the pot has returned to touch-dry the slip is turned (or scraped) off all surfaces to reveal the inlaid pattern. On some pieces slip trailing is done directly onto the leatherhard clay body – no background slip is used.

Technical information

Clay	For inlaid ware – mixed stoneware clay and fine earthenware clay from Medcol Cornwall. For slip-trailed ware – from W.J. Doble Pottery Clays.	
Slip	**White slip**	
	Ball clay	6
	China clay	4
	Flint	1
Glaze	**Celadon**	
	China clay	18
	Feldspar	12
	Flint	12
	Whiting	8
	Ochre	1
	Ash	
	Feldspar	6
	Ash	3
	Flint	1
Firing	Work is reduction-fired to Orton cone 9 (1270°C/2318°F) in a gas kiln.	

Inlay process by Motoko Wakana showing patterned bowls before and after covering with slip. PHOTOGRAPH BY MOTOKO WAKANA.

Inlay process by Motoko Wakana showing patterned bowls before, during and after removal of the slip. PHOTOGRAPH BY MOTOKO WAKANA.

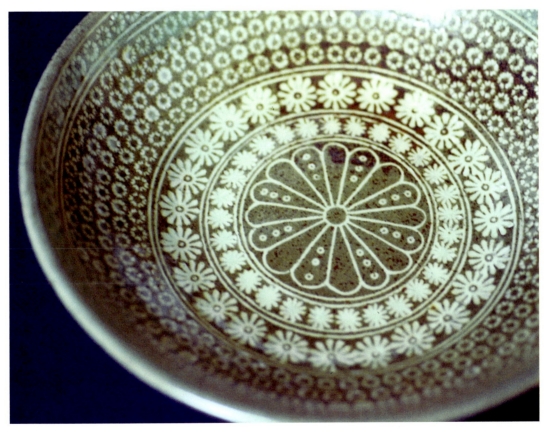

Inlaid Chrysanthemum dish by Motoko Wakana, (d. 26 cm/10¼ in.). PHOTOGRAPH BY MOTOKO WAKANA.

Fritz Rossmann (GERMANY)

Fritz Rossmann makes a range of mainly individual pieces in porcelain using a variety of celadon glazes.

Before studying at the National School of Ceramics in Höhr-Grenzhausen, western Germany, Fritz worked as an apprentice at Pottery Wim Mühlendyck, making salt-glazed wares. After graduating he taught for a time at the University of Giessen, and has exhibited widely, including in China, Taiwan, Japan, New Zealand and the USA; he has work in many national collections. He is known in the UK through exhibiting and demonstrating at Art in Action and at the National Ceramics Festival.

Working methods

Most potters use porcelain for its translucent qualities, and even if it isn't thin enough to allow light to travel through, its characteristics give the glaze a luminosity that would be lacking with any other clay; putting a slip on porcelain would completely mask these properties. For Fritz, however, a black engobe is a major feature of his work. It may accentuate the foot of a bowl, punctuate a tall compound vase, emphasize the central hollow on shallower pieces, or be used to cover the neck and take the eye to the top of the pot. By absorbing a little iron from the engobe, the glaze can take on a slightly darker shade where the two overlap.

Fritz has developed an evolving range of individual pieces in porcelain using several celadon glazes. These are applied singly, and over or under each other, for different effects, depending upon the varying amount of crackle each glaze brings to the finished piece. Most pots are thrown, with some built from slabs using several different porcelain bodies, including Southern Ice, which is particularly translucent. For the compound vases, which are assembled when leather-hard, Fritz uses high-fire Limoges for the lower part to avoid deformation; this clay can be fired to 1400°C/2552°F.

Vase forms with black engobe by Fritz Rossmann, (h. max. 35 cm/13¾ in.) PHOTOGRAPH BY HELGE ARTICUS.

Technical information

Clay Different porcelain bodies, including Southern Ice and high-temperature Limoges.

Engobe

White stoneware clay	40
China clay	40
Feldspar	20
Frit	10
Black stain	6

This can be used on raw clay or biscuit ware.

Glaze **Heavy crackle celadon**

Nepheline syenite (or Cornish stone)	66
Calcium carbonate	10
Dolomite	10

China clay	10
Zinc oxide	2
Barium carbonate	2
Red clay	10
(or 0.5 iron oxide)	

Firing Biscuit firing is to 1015°C (1859°F), glaze firing to 1280°C (2336°F) in a one cubic metre gas kiln.

Tall vase forms with black engobe by Fritz Rossmann, (h. max. 62 cm/24½ in.).
PHOTOGRAPH BY HELGE ARTICUS.

Megan Collins (UK)

Megan makes individual pieces in reduced stoneware. She discovered clay by going to evening classes (taught by Vanessa Cox Pendry) with her father while still at school, subsequently working with clay for GCSE and A-level Art. She graduated from Loughborough University in 2008, and was the Student Award Winner at the National Ceramics Festival that year.

Megan says she is 'fascinated by the ever-changing landscape sculpted by the elements, particularly by the sea. I try to capture some of this beauty through surface texture and glaze.' This can be seen in the variegated

Megan Collins, Student Award Winner at the National Ceramics Festival 2008. PHOTOGRAPH BY JOHN MATHIESON.

finish she gives to her pieces, whether they are vessel forms or wall pieces. She is also influenced by artists such as Claude Champy, Robin Welch and Peter Voulkos.

Working methods

Megan uses a combination of handbuilding techniques, often incorporating throwing. Her work is mainly once-fired, allowing her to apply slips and glazes as she is making; she feels this gives more fluidity to the process. If she is not happy with results she will apply more glaze and re-fire. 'I enjoy the excitement of opening the kiln to see how the raw flame has developed the glaze, and the drips which have formed. I particularly like the seemingly gravity-defying movement formed by side-firing'.

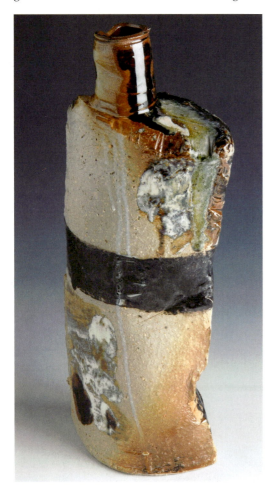

Pot by Megan Collins, handbuilt with thrown addition, (h. 32 cm/12½ in.). PHOTOGRAPH BY ALAN DUNCAN.

Note: Pots can be fired on their sides, on shells packed with clay, to give support. A ridged shell can leave marks on the glaze or clay surface, which eventually forms part of the surface decoration and texture on the pot. The shell itself goes powdery during the firing, and comes away easily. This technique is most widely used in wood-firing, during which the ashes will land on pots and melt, forming a glaze which, if thick enough, will run and drip. It is how the Chinese discovered glaze.

Technical information

Clay	Heavily grogged white stoneware with added paper fibres.	
Slips	**White slip 1**	
	White casting slip, brushed and spattered onto the pot.	
	White slip 2	
	Potash feldspar	60
	Quartz	60
	Whiting	40
	Titanium dioxide	15
	Zinc	5
	Black slip	
	Soda feldspar	120
	Whiting	30
	China clay	15
	Red iron oxide	10
	Cobalt carbonate	3
	Chrome oxide	3
Glaze	**Clear raw glaze**	
	Quartz	30
	Hyplas ball clay	28
	Whiting	19
	Potash feldspar	15
	Talc	7
Firing	Megan reduction-fires to cone 10 (1290°C/2354°F) in a Laser kiln using natural gas.	

Rachel Wood (UK)

Rachel Wood is known for her highly individual pieces in stoneware, which may be coiled, slabbed or thrown, and are frequently distorted during the making process.

After taking a degree in modern languages and working at a variety of jobs, Rachel was inspired by a summer school for drawing to take an art foundation course. This was followed by a degree in Ceramics at Loughborough University. She is amazed at the positive transformation in her life, and values it all the more because of that.

A significant influence on her work is that of Ryoji Koie. Until she had seen his pieces Rachel was convinced that her direction lay in working with slabs, but the energy she found in his work, and its distance from conventional ceramics, captivated her – 'I loved the spontaneity and physicalness of throwing in a very free and unrestrained way'.

Rachel was 'drawn to matt and rough surfaces'; she has travelled extensively in Australia and was 'gripped by the amazing landscape, exaggerated colours and forms'.

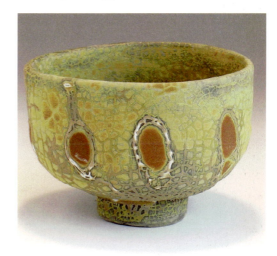

Tea bowl by Rachel Wood, vanadium slip and barium glaze, (d. 10 cm/4 in.). PHOTOGRAPH BY DAVID BINCH/OAKWOOD CERAMICS.

115

Rachel Wood in the studio at Rufford Craft Centre. PHOTOGRAPH BY RUTH HALLAM.

Slip tests by Rachel Wood prior to biscuit firing. PHOTOGRAPH BY DAVID BINCH/OAKWOOD CERAMICS.

For several years she used a vanadium pentoxide slip that gave her 'distinctive green, crazed and thirsty surfaces'. However, following a period working with Robin Welch, and a residency at Rufford Ceramic Centre, she re-evaluated the direction her work was taking.

She wanted earthy tones and gritty, uneven textures achieved using slips over coarse clays, with multiple firings, and has developed a new body of work which, while clearly showing continuity with earlier pieces, is original and evolving.

Working methods

Rachel uses a variety of making methods in her work. Much is thrown on a Shimpo wheel, and built up in sections for tall 'funnel' pieces. Some thrown cylinders are cut down vertically in one place and stretched to make platters and vases. Jewellery is made from blobs of clay flattened with a rolling pin. Tall bowls start with a pinch pot and are built up with flattened coils; the clay at the top is 'stressed' and worked in different stages of drying to get cracks and fissures. Most pieces are distorted in some way. 'I don't hesitate to use my hands and fingers to apply marks at any stage of the process. For example, if when lifting [a piece] off a batt or the table my finger makes a mark, then it stays – nothing is removed'.

This same approach applies when Rachel is glazing pots – the accidental is actively encouraged. The fingermarks on the matt-green pieces started for purely practical reasons, to enable her to grip the piece when dipping in the glaze. Her fingers acted as a resist, and a thicker circle of glaze formed where it collected around her fingertips. On her other work, a variety of slips and glazes may be used on the same pot, resulting in a weathered look, as if the pieces are the result of natural erosion.

Technical information

Clays Raku, crank and any kind of smooth stoneware.

Slips **Pinkish to dark brown**
Ball clay + 8% manganese dioxide

Reddish brown
Ball clay + 10% iron oxide

Blue-black
Ball clay + 3% copper oxide

Green-ochre
Ball clay + 10% vanadium pentoxide

Note: Vanadium pentoxide needs to be handled with extreme care! Rachel always wears a mask and gloves when using this slip.

Glazes Barium

Barium carbonate	45
Nepheline syenite	45
Potash feldspar	10

This reacts well with the vanadium pentoxide slip, but has very little reaction when applied over other slips.

Dolomite white

Potash feldspar	60
Whiting	12
Dolomite	10
China clay	10
Tin oxide	8

This gives a white sheen, opaque, smooth and soft to the touch.

Opaque

Potash feldspar	60
Dolomite	20
China clay	20

This is similar to Dolomite, but not as white or dense.

Cobalt

Nepheline syenite	30
Flint	25
China clay	20
Dolomite	10
Barium carbonate	10
Talc	5
Cobalt carbonate	1

Coiled bottle by Rachel Wood with layered slips and assorted glazes (h. 45 cm/17¾ in.).
PHOTOGRAPH BY DAVID BINCH/OAKWOOD CERAMICS.

This is used in moderation for relief and colour.

Firing Pots are biscuit-fired to 1000°C (1832°F) and glaze-fired to 1260°C (2300°F) in an electric kiln.

Roger Cockram (UK)

Roger Cockram makes a range of individual pieces and some domestic ware in his studio at Chittlehampton, Devon. His first degree was in zoology, with postgraduate studies in marine biology, the influence of which is very evident in his work today.

When Roger was teaching, one of his 6th-form students would always disappear at lunchtime. Out of curiosity Roger followed him – to the pottery studio, where the student made pots for an hour. Roger had a go, and so began his lifelong fascination with ceramics. After a steep learning curve, and three years at Harrow on the Studio Pottery course, Roger returned to North Devon and established his own workshop. For the first ten years he made wood-fired domestic stoneware, but with the recession of the 1980s his porcelain pieces became the mainstay.

It was towards the end of the 80s that Roger rediscovered his interest in marine and freshwater life, and in the movement of the water itself. He began drawing and painting what he saw, and the combination of this with his passion for clay resulted in the work for which he is now internationally known. A bowl perhaps 60 cm (24 in.) across may depict a whirlpool, while many of his forms carry images or relief models of fish, frogs, lobsters and other aquatic animals which capture the movement and the spirit of the creatures shown.

Bowl by Roger Cockram. PHOTOGRAPH BY ROGER COCKRAM.

Mike Dodd (UK)

Detail of vitreous slip by Roger Cockram.
PHOTOGRAPH BY ROGER COCKRAM.

Mike Dodd makes individual pieces and some domestic ware in reduced stoneware. Like Jim Malone, Mike is part of the 'Leach tradition' of Anglo-Oriental pottery.

At school, Mike was taught ceramics by Donald Potter, who showed his students work by Cardew and Hamada, and introduced the ideas of Bernard Leach. He was sufficiently inspired to continue his interest in clay whilst reading medicine at Cambridge University. After three years at Cambridge (and with a degree), Mike left to take an uninspiring pottery course in London, which he abandoned after a year to set up his own pottery in Sussex.

Mike has had a number of workshops, including in Cumbria where he taught with Jim Malone; he is now settled at the Dove Workshop, Glastonbury, in Somerset. He has exhibited widely, including a recent major exhibition of 170 pots at the Goldmark Gallery, Uppingham.

Working methods

Roger's work is initially thrown on the potter's wheel. Depending on the ideas being incorporated into the design, the rim may be carved, and the wall pierced or engraved to give the effect of slightly raised images. Separately modelled features such as a crawling frog or a leaping salmon may be added to give a further three-dimensional impact to the piece.

Roger has always once-fired his work. It is decorated with multiple layers of vitreous slips and glazes, which are often sponged onto the pot, his intention being to give a feeling of depth to the surface.

Technical information

Vitreous slips Vitreous slips are standard slips (for instance, Hyplas 71 ball clay) to which a small amount of flux (for instance, borax frit) has been added. By experimenting with different oxide additions or commercial body stains a wide range of colours can be achieved.

Firing Roger reduction-fires to cone 11 bending in a gas kiln. (Cone 11 = 1300°C/2372°F).

Working methods

Mike works on a momentum wheel, the quietest wheel I've ever heard, so quiet you can hear the clay between your fingers. His throwing is loose, with soft clay, which may be marked with a variety of tools, including roulettes, stamps and paddles. Ridges of clay may be added to highlight the form, while other pots are cut-sided or fluted. Sgraffito is used – often boldly – directly onto the clay surface, and through slips, or finger-wiped. Wax resist is used between layers of different glaze. Mike makes extensive use of local materials in his slips and glazes.

Mike uses a technique in which dry powdered clay is sprinkled on the wet surface of a freshly thrown pot, where it forms a skin; in effect this is a dry slip. Throwing then continues with pressure from

119

the inside only, causing the dry surface to crack and open, resulting in a glazed pot which has a fascinating texture. (**Note:** be extremely careful if you try this – clay dust is dangerous to inhale, see p.137).

Technical information

Clay DSS from W.J. Doble Pottery Clays

Slips **White slip**

Hyplas 71 ball clay	60
china clay	40

Applied when the clay is leatherhard.

Crackle slip

A mixture of feldspar and china clay which is applied faitly thickly to biscuit-fired pots. Any decoration (e.g. sgraffito, finger wipes) must be done within thirty seconds or the slip will dried too much. The pot must be glazed when the slip has lost its gloss – if left too late the slip/glaze layer will crack off.

Firing Mike biscuit fires to cone 07 – 05 (980–1040°C/1796–1904°F) and glaze fires in reduction to cone 10 (1290°C/2354°F) with a rdeucing atmosphere in an oil-burning kiln.

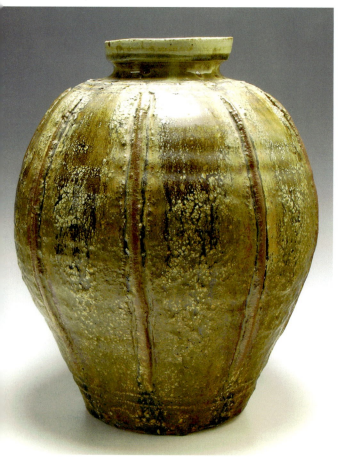

Top: Tea bowl by Mike Dodd. After turning, the pot was dipped in a dark local clay slip. The white slip (a clay/feldspar mix) was applied after biscuit-firing and brushed with a Chinese hearth brush made from rice straw. The glaze is a porphyry stone/ash mix. PHOTO BY JOHN MATHIESON/AUTHOR'S COLLECTION.

Author's note: I have achieved similar colours using an ash glaze over a porcelain slip (see vase, p.7).

Left: Jar by Mike Dodd with 'dry slip' decoration. PHOTOGRAPH BY DAVID BINCH.

Rebecca Harvey (UK)

Rebecca Harvey established her reputation making elegant soda-glazed tableware with distinctive features such as twisted handles and extruded spouts on teapots. More recently she has completed a master's degree at the Royal College of Art in London, where she explored both porcelain and glass, making asymmetrical objects often combining both materials.

After taking her first degree at Cardiff College of Art she set up her own studio in Cambridge. Her work was inspired particularly by Japanese ceramics, and 18th-century creamware. In addition to potting, she qualified as a teacher; like many potters she has combined making and teaching.

At the Royal College, Rebecca developed a way of making handles by slip-trailing on plaster batts. This work was inspired by an 1895 cup and saucer with 'a beautifully delicate butterfly handle' made in the Sèvres style by Mintons in Stoke-on-Trent and seen in the Fitzwilliam Museum in Cambridge. She trailed layers of slip one over the other on a batt until the desired shape and thickness had been achieved. When this was dry enough to release, it was lifted from the batt and attached to the thrown cup – the surfaces to be joined were first scored and then thick slip applied before the handle was

Cup and saucer with plate and dish by Rebecca Harvey (cup & saucer h. 11 cm/14¼in.). PHOTOGRAPH BY ADRIAN NEWMAN.

Cup with trailed handle and saucer by Rebecca Harvey, (h. 8.5 cm/3¾ in.). PHOTOGRAPH BY ADRIAN NEWMAN.

pressed into place. The pieces were then dried slowly under a muslin cover.

Rebecca now has her own studio in Hayle, Cornwall, and shares facilities at the Gaolyard Studios in St Ives; she exhibits at the Leach Pottery and St Ives Ceramics.

Working methods

All of Rebecca's work is thrown on a Shimpo wheel. Delicate objects are subsequently turned when leatherhard, while one-off sculptural objects are carved on the wheel using a range of wires.

Her earlier salt-glazed pieces were very precisely made, and incorporated extruded handles and spouts. Latterly, using porcelain, her work has become much looser and freer, with the throwing seen much more as a starting point for further development. Some thickly thrown dishes appear almost geological, with torn and fractured edges surrounding a smoothed central area.

Technical information

Clay	Valentine's Special Porcelain
Slip	Slip for the trailed handles and bases is made from the body clay.

Glaze **Clear glaze**

Potash feldspar	20
Whiting	20
Nepheline syenite	15
China clay	15
Quartz	15
Talc	10
Bone ash	2

Firing Rebecca biscuit-fires to 980° C (1796° F) and glaze-fires to 1260°C (2300°F) with a 15-minute soak in an electric kiln.

John Mathieson

I make individual pieces and some domestic ware, currently mainly in stoneware using slipware techniques.

I discovered ceramics totally by accident at evening classes in London and instantly became hooked for life. In less than a year I began teaching ceramics and art at secondary level in Northampton. Since then, I have taught in an upper school, in a college and in prison (far easier than school). Although I left full-time education some time ago, I still teach adult classes. Whilst teaching I was given secondment for a year to take a degree (my tutor was James Bassett, *q.v.*), which gave me the opportunity to develop my work and to fire with gas for the first time.

I have worked extensively in slipware, stoneware, some porcelain and raku. I sometimes envy those potters who stayed with one (hopefully evolving) way of working,

Stoneware tea bowl by John Mathieson, (h. 9 cm/3½ in.), talc glaze over Fremington slip. PHOTOGRAPH BY JOHN MATHIESON.

but this is how it has been for me. Initially I was very influenced by the Leach tradition, and later by Michael Cardew, Peter Dick and Clive Bowen. I also greatly admire potters such as Nic Collins, whose anagama-fired pieces tell a story as you turn them in your

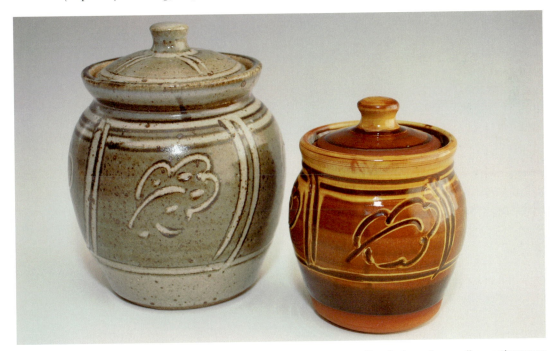

Storage jars by John Mathieson, larger stoneware with talc glaze over Fremington slip, smaller earthenware with lead sesquisilicate glaze over HVAR slip, (max. h. 18 cm/7 in.). PHOTOGRAPH BY JOHN MATHIESON.

hands. And this perhaps is the key – I like pots that carry the mark of the maker's hands, evidence of the journey they have made. I have been told that even my porcelain pieces look like pots, that they don't have the over-finished result often found with this material.

Working methods

Most of my work is thrown on a Leach kickwheel – I like its slowness, its responsiveness, and the fact that I kick the treadle faster or slower as required without giving it any conscious thought. I work with soft clay, clay with a medium texture – a bit of tooth, because I like to feel the clay between my fingers. I turn most pieces – I find it an expressive part of the whole making process, and I like to see marks from the tools I use as they happen, and not in any contrived way.

Pots are usually dipped in slip at the leatherhard stage or softer, and I draw through the slip as soon as the wet sheen has disappeared. This is the process I enjoy most, when the marks reveal the contrasting clay body under the slip and hopefully bring the pot to life. I use sgraffito to make what Michael Cardew called 'punctuation marks' that try to enhance the form and take the eye into the shape. They work best when they have been done many times, when they are loose and not perfect – when they are a movement and no longer an idea.

The dark slip I use is made from Fremington red clay, a low-temperature body that starts to deform at around 1100°C (2012°F). It interacts well with my main (talc) glaze and gives great variation – if I make 20 coffee mugs (a rare event), there can be a wide variation of colour and all will be different.

Occasionally I experiment with Doble's Black Iron stoneware body, which gives dramatic colours in my gas kiln. I do not glaze the outside; the decoration is 'splash lines' using porcelain slip.

Technical information

Clay For stoneware I use DSS from W.J. Doble Pottery Clays, St Agnes, Cornwall. It throws well and has an attractive 'toasted' colour in reduction firing; it can be used in an electric kiln.

For earthenware I use Valentine's 10% grogged terracotta. For a long time I used Potclays 1137 red earthenware – it was the standard clay in the school where I taught and gave good results.

Slips **Black slip**

Fremington red clay	100
Iron oxide	4
Manganese dioxide	4

This is a standard recipe used by many potters; some add cobalt oxide. Fremington clay is no longer commercially available, but any red clay will work.

Buff slip

Ball clay	100

White slip

Porcelain	100

Glazes **Talc glaze**

Potash feldspar	5
Ball clay	3
Whiting	1
Talc	1

This is transparent but not glassy – it gives a restrained gloss sometimes described as a buttery texture. It reacts well over black slip, and rarely runs. Fired to Orton cone 10 (1290°C/2354°F) in a gas kiln, but it will work in an electric kiln. If red clay is substituted for ball clay it looks very similar to an ash glaze.

Shino

Nepheline syenite	80
HVAR ball clay	20
Bentonite	2

This is a hard white glaze, good over slip. It will work with any ball clay.

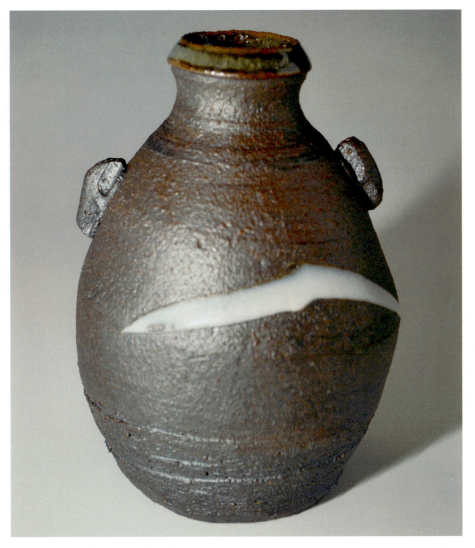

Black clay bottle by John Mathieson, with unglazed exterior and porcelain splash line, (h. 12 cm/4¾ in.). PHOTOGRAPH BY JOHN MATHIESON.

The bentonite is essential to stop the glaze setting like a rock in the bucket.

Firing I fire in a propane-burning Laser kiln to 980°C (1796°F) for biscuit, and to 1290°C (2354°F) by cone for glaze. I reduce from 1000°C (1832°F) until nearly at top temperature, and take the last hour of firing very slowly – in effect a soak. The firing ends when Orton cone 10 is over and cone 11 is just starting to bend.

Note: The excellent Leach wheel is no longer made in the UK, but is available new in the United States; occasionally used wheels are advertised in the small ads in *Ceramic Review*, and there are plans for the wheel in Andrew Holden's *The Self-Reliant Potter*, sadly out of print.

Bottle by John Jelfs (h. 35 cm/13¾ in.), dipped in slip and soda-fired. PHOTOGRAPH BY JUDE JELFS.

9 Slips with Salt and Soda Glazing

The terms 'salt glazing' and 'soda glazing' refer to the practice of introducing common salt (sodium chloride) or sodium bicarbonate into a dedicated flame kiln at temperatures in excess of 1230°C (2246°F). Pots are fired without any exterior glaze, though the interior is usually raw-glazed. The salt or soda fumes combine with the clay to produce a surface that characteristically has an orange-peel texture, though there can be great variation and this is by no means always the case. Sodium bicarbonate is sprayed into the kiln, while salt is normally introduced in paper wraps.

Different slips will give a wide range of colours and have a major effect on the glaze. The technique emphasises textures, and potters often exploit this by, for instance, using extruded ridged handles, which will show great variation in glaze colour and thickness.

For more information about this specialist way of firing see the books by Rosemary Cochrane and Phil Rogers listed in the Bibliography.

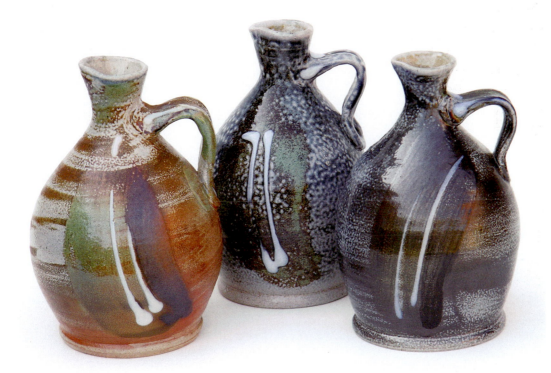

Salt-glazed oil jugs by Mirka Golden-Hann (h. 13 cm/5 in.). PHOTOGRAPH BY MIRKA GOLDEN-HANN.

John and Jude Jelfs (UK)

John and Jude Jelfs work together in their pottery in Bourton-on-the-Water, a delightful village in the Cotswolds, complete with a broad stream running down the main street. After seeing pots being thrown in Mumbai while he was working as a ship's engineer, John was inspired to study ceramics at Cheltenham College of Art, establishing his own pottery in 1973. All John's work is functional or functionally related, and most is thrown. He cites Bernard Leach, Shoji Hamada and the eastern school of pottery as his major influences; their strength, he feels, lies in their quietness. His own work has a wonderful elegance, with the forms enhanced by the slips and glazes he uses.

While much work is reduction-fired stoneware, a few years ago John built a gas-fired soda kiln; pots from these firings feature increasingly in his displays.

Note: I have written about Jude's work in earthenware in the section on Using Slips Without a Glaze (see p.44).

Working methods

Almost all John's work is thrown. He uses ash, celadon, ochre, tenmoku and shino glazes, incorporating wood-ash and local clays. Slips are applied when work is leatherhard.

The thrown pieces may be modified by, for example, vertical lines drawn down the side of a jug, or small indentations and slightly raised stamps on a bottle or teabowl. John sometimes combs through slip (see the photograph of a jug) to reveal the contrasting clay body, slip and body reacting differently in the soda firing. All are subtle features designed to complement the form in a quiet way.

Technical information

John Jelfs clay body

ND ball clay	50
FR ball clay	50
80s mesh silica sand	3

This is dough-mixed and vacuum-pugged, then left for at least a month to mature.

Jude Jelfs clay body

	T-Material	50
	Scarva Flax Clay	50
Slip	BLU ball clay	50
	China clay	50
	Nepheline syenite	20
Firing	John and Jude soda-fire to cone 10 'touching toes' (1290°C/ 2354°F).	

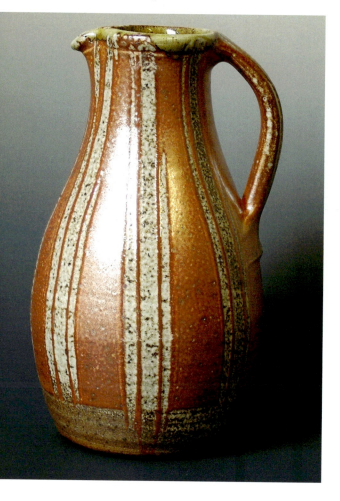

Left: Jug by John Jelfs, with combed slip, soda-fired, (h. 33 cm/13 in.). PHOTOGRAPH BY JUDE JELFS.

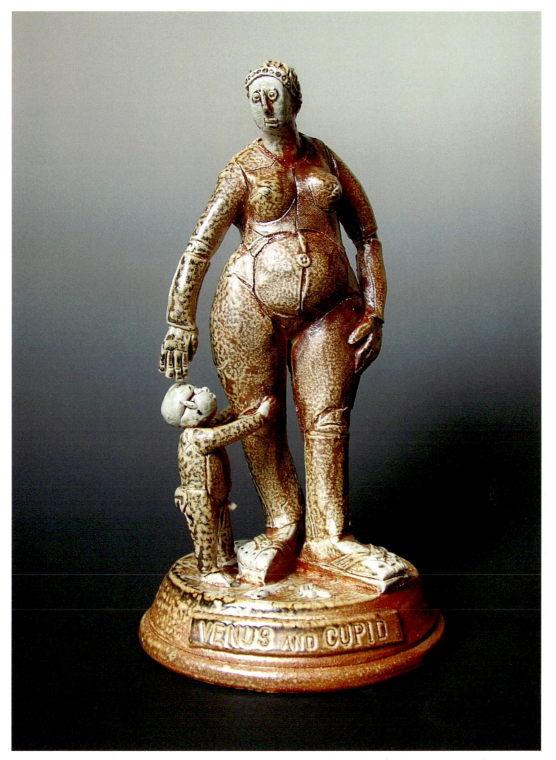

Venus and Cupid by Jude Jelfs, slipped by brushing, soda-fired, (h. 36 cm/14¼ in.). PHOTOGRAPH BY JUDE JELFS.

Reuben Batterham
(UK/FRANCE)

In his workshop in eastern France, in a hamlet near the village of Chaumont in a beautiful setting not far from the Swiss border, Reuben Batterham makes both domestic ware and individual pieces in high-fired stoneware and salt glaze.

Reuben was born into a potting family in Dorset, England – both his parents, Richard and Dinah Batterham, had trained with Bernard Leach in St Ives; Leach, Michael Cardew and Katherine Pleydell-Bouverie were all visitors to the home. After leaving school Reuben worked during the winters for four years with his father and with the French potter Thiebaut Chague, while summers were spent as a cook in French restaurants. He established his first workshop in Ravilloles in the Jura in 1992, and ten years later moved to Chaumont. He exhibits occasionally in the UK at the Southern Pottery and Ceramics Show at Farnham, and at a private venue in Bath.

Working methods

The workshop is equipped with a momentum wheel, a pugmill, plenty of shelving, and a two-chambered oil-fired kiln of about 4 cubic metres, which is fired three times a year. The first chamber is for glazed work, the second for salt – approximately one-third of the pots are salt-fired.

All Reuben's pots are made on a kick wheel. He decorates using a variety of methods on the unfired pot, including paddling to give flattened sides, indenting vertically with the

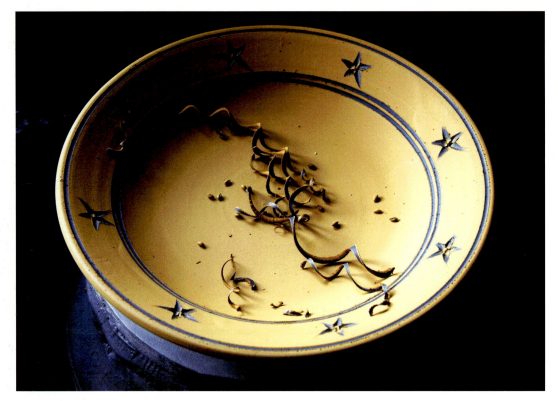

Plate by Reuben Batterham with decoration incised through layers of slip. PHOTOGRAPH BY OLIVIER ROYDOR.

Above: 'Chatter' tool used by Reuben Batterham. PHOTOGRAPH BY OLIVIER ROYDOR.

Right, from top: Detail of chatter decoration on a teapot by Reuben Batterham. PHOTOGRAPH BY OLIVIER ROYDOR.

Chatter decoration on the interior of a salt-glazed bowl by Reuben Batterham (d. 14 cm/ 5½ in.). PHOTOGRAPH BY JOHN MATHIESON/AUTHOR'S COLLECTION.

Large unfired slip-decorated jars by Reuben Batterham. PHOTOGRAPH BY OLIVIER ROYDOR.

edge of a piece of wood, and cutting lines through bands of slip to reveal the clay body beneath. Chatter decoration (see photographs) is a feature of Reuben's work, as is the use of different colour bands of slip to give, for instance, a bowl with dark sides and a light-coloured rim. He uses four different slips, and around six glazes.

Technical information

Firing Biscuit firing is between 910°C (1670°F) and 960°C (1760°F), depending on where the work is placed in the chamber. Glaze firing is to 1320°C (2408°F).

Mirka Golden-Hann
(Czech/UK)

Mirka Golden-Hann makes domestic ware and some sculptures in salt-glazed ceramics. She came to the UK from the former Czechoslovakia in 1993 and studied at the University of Westminster (Harrow campus) where she gained a BA in Ceramics. The course at Harrow has had outstanding teachers, and produced graduates who went on to become some of the leading potters of their generation. In the summer she graduated, Mirka was given the 'Best Student' award at the National Ceramics Festival in the UK – I particularly remember her large, vigorously thrown dishes from this time.

Since then Mirka has built her own salt-glaze kiln and exhibited at many shows. Her work clearly demonstrates the effect and colour of different slips when used in salt glazing, an area she researched in even greater depth for her MA.

Mirka feels strongly that, 'The prerequisite of learning and progressing is an open mind – everything and everyone is a potential influence. The more I work with clay, the more I have noticed that it is not just the skill that creates, but mainly the maker's personality. My work is a refection of myself at this point in my creative life.'

Working methods

Mirka works in a very direct and expressive way with the clay on her wheel, an approach perhaps best seen on her dishes, where the rim may be grooved and indented, and the marks of the throwing rib left to be part of the decoration. She writes:

'Throwing, distorting and assembling is the way I create my forms. I like to capture the energy of freshly thrown clay. Sometimes I like to mark and decorate the clay as I throw, using the wheel as part of the decorating process; at other times I like to explore the potential of decorating the smooth surface, textured by the salt. I use slips on top of soft clay, because the process of integrating the decoration with the making is very important for me.'

This same directness can be seen in her motifs – the pattern is structured but kept loose, which allows for considerable variation within a theme. Multiple slips are used – spirals may overlay a broader, softer brushstroke, slip may be brushed loosely round or inside a pot with a stronger contrasting colour trailed or brushed on top, while two parallel lines of either white or black slip provide a focal point.

Mirka once-fires in a propane kiln of approximately 1 cubic metre packing space. As

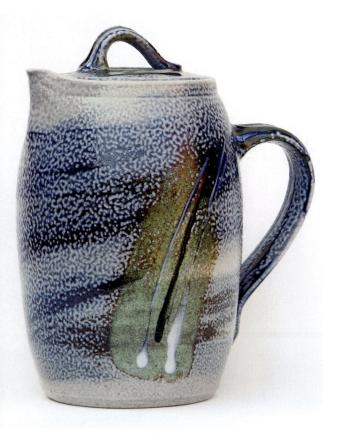

Salt-glazed coffee pot by Mirka Golden-Hann, (h. 19 cm/7½ in.). PHOTOGRAPH BY MIRKA GOLDEN-HANN.

Large salt-glazed dish by Mirka Golden-Hann, (d. 32 cm/12½ in.). PHOTOGRAPH BY MIRKA GOLDEN-HANN.

the salt vapour is present throughout the kiln, pots are placed on salt-resistant wads to prevent them from sticking to the shelves. The space left between pots is important for glaze formation – a close pack will promote flushing, while wider gaps will result in a more even surface. 'The technique of salt-firing fits very well with my work philosophy. With salt glaze there is an element of unpredictability – the kiln itself plays a major role in the forming of the work.'

Technical information

Clay **Doulton salting body**

BBV ball clay	62.5
China clay	18.75
Potash feldspar	18.75

Harry Davis salting body

Hyplas 71 ball clay	74
China clay	24
Cornish stone	1

A more vitreous version:

Hyplas 71	75
China clay	12.5
Nepheline syenite	12.5

These recipes are without filler – grog, molochite or sand can be added to them.

Slips Mirka points out that any oxide, or mixture of oxides, or any glaze body or stain (or their mixtures), may be used in salt-glaze slips, with interesting results.

Dry oranges, yellows and pinks
Try mixtures of various ball clays and china clays. These can give good

133

results, for example:

AT ball clay	20
China clay	80

AK ball clay	40
China clay	60

SMD ball clay	50
China clay	50

Porcelain	75
China clay	25

Fireclay	20
China clay	80

This produces a fierce orange colour.

Porcelain	20
China clay	10
Tin oxide	3

Porcelain	98
Illmenite	2

Browns

Experiment with red clay and china clay mixtures, plus iron oxide.

Shiny brown

Red clay	50
BBV ball clay	40
Flint	10

Pure white

Hyplas 71 ball clay	25
China clay	25
Flint	35
Cornish stone	15

Rich glossy or fluid oranges

(1) AT ball clay	60
Potash feldspar	20
Whiting	10
Flint	10
Rutile	10
Red iron oxide	5
(2) SMD ball clay	75
Grolleg china clay	25
Vanadium pentoxide	15
Titanium dioxide	10
Tin oxide	10
(3) AT ball clay	63
Nepheline syenite	32

Flint	5
Zirconium silicate	5
Titanium dioxide	10

Base slips for colourants to be added

(1) China clay	30
SMD ball clay	40
Flint	15
Nepheline syenite	15
(2) Nepheline syenite	50
Hyplas 71 ball clay	50

Colourants

8% Rutile – produces pearl/tan

5% Titanium dioxide – produces pearl

0.5–3% Cobalt carbonate – produces blue

6% Rutile + 3% Cobalt carbonate – produces green

6% Manganese dioxide – produces brown

10% commercial stain can be added to both the above recipes

Raw lining glaze

Note: Because the salt fumes do not penetrate the inside of containers, pots for salt firing are given an interior 'lining' glaze. This is applied to the leatherhard pot, usually by pouring.

(1) Nepheline syenite	1
AT ball clay	1
Soda feldspar	1
(2) Nepheline syenite	1
AT ball clay	1
China clay	1
(3) Hyplas 71 ball clay	1
Potash feldspar	1
Cornish stone	1

Firing The firing begins slowly. Reduction starts at 1000°C/1832°F, with salt being introduced in paper wraps at the burner port at 1240°C/ 2264°F. She fires to Orton cone 9 (1270°C/ 2318°F), and likes to have cone 10 still standing when the firing is over.

Clive Bowen – pots from the kiln. PHOTOGRAPH BY JAY GOLDMARK/GOLDMARK ART.

Glossary

Bentonite is a highly plastic montmorillonite with many uses. It is listed in this book as a glaze suspender.

Burnishing – polishing the surface of the leatherhard pot with the back of a spoon or a smooth pebble.

Celadon – glazes varying from pale to olive-green, and is particularly associated with porcelain.

Chamotte is grog, added to clay in varying sizes and quantities to aid workability.

Cones measure 'heat work' (the work the heat has done inside the kiln) rather than the actual temperature; they bend to indicate the point in the firing that has been reached. Usually cones are used in threes, e.g., cone 8 as the guard showing that the kiln is approaching top temperature, cone 9 as the optimum firing point, with cone 10 to indicate if the kiln has over-fired.

Crackle/crazing are essentially one and the same thing. Crazing is fine cracks in the glaze, and crackle is this same feature used to decorative effect. The Chinese used ink to emphasise the crackle; in raku firings smoke gives a similar result. Cracks in the glaze occur because the glaze contracts more than the clay body after firing.

Crank clay is a coarse handbuilding clay, usually incorporating grog of different sizes, and excellent for large structures.

Foundation course is a one-year course that students in the UK must pass before embarking on an art degree of any kind. It involves studying a variety of media in depth.

Fremington clay is from North Devon and sadly no longer commercially available. Fremington clay starts to vitrify around 1100°C (2012°F). Although it has its idiosyncrasies, being prone to s-cracks across the base if sand or grog isn't added, it is by far the best throwing clay I have ever used.

Greenware is unfired work.

Grog is a fired and ground clay body added to clays to improve workability.

Molochite is china clay of different grades pre-fired to at least 600°C (1112°F) to remove its plasticity.

Oxides are metal oxides and carbonates added to slips and glazes to give colour and, in some instances, opacity to a glaze. For example, the addition of copper oxide and copper carbonate will produce a green slip or glaze; the addition of titanium dioxide will result in an opaque cream-coloured glaze.

Raw glazing (also known as **once-firing** and **single-firing**) involves applying glaze to work before it has been fired, and then only firing once, to glaze temperature. Glazes are applied at the leatherhard stage and contain a high proportion of clay in order to maintain shrinkage compatibility with the body.

Reduction - literally reducing the amount of oxygen in the kiln. The flame, hungry to burn, will take oxygen molecules from the clay and the glaze, and in doing so change the colour.

Serif is a slight projection finishing off the stroke of a letter.

Slipcasting is a method of producing pieces by pouring slip into a specially constructed plaster mould, where the slip forms a layer on the inside of the mould, and the excess is drained off, enabling repeat forms to be created.

Slip trailer is a rubber bulb with a fine nozzle used to apply slip to a pot, especially for lettering.

Soak allows the kiln to stay at top temperature (for anything between 10 minutes and two hours or longer) to enable the body and glaze to mature, and the glaze to settle.

T-material is a high-quality stoneware that incorporates molochite grogs, and fires to an off-white colour. Some manufacturers offer cheaper alternatives.

Health & Safety

Good Workshop Practice

Health and safety in pottery is really applying common sense to the handling of the materials, and to the working situation. We use potentially dangerous chemicals and equipment in our domestic lives every day without coming to harm, and it should be the same with ceramics. Some basic rules (they are all straightforward) should be observed as a matter of habit:

- For your own good health, *always* wear a quality face mask when handling dry or powdered materials. Clay dust can cause silicosis, while some oxides can also be harmful. Glaze materials can also be very hazardous in powder form.

- Label bags of materials with a permanent marker – stick-on labels don't last forever, and many glaze constituents look very similar.

- A powerbreaker is *essential* when using electrical equipment to mix slips and glazes.

- Buckets of slip and glaze should be labelled on both the lid and the side – I write the recipe on thin card with a waterproof pen, and this is covered with sticky-back transparent film.

- Always close and seal bags and containers after use.

- Wash down benches after use, and wipe up any spilled materials before they dry and become dust.

- Always wash your hands after handling ceramic materials, and never eat, drink or smoke in the workshop.

A note on lead release from glazes

Lead in glazes produces beautiful colours that have a depth and richness impossible with substitute materials. However, if you put lead glazes on work designed for use with food it must be laboratory-tested for lead release – this is a legal requirement in the UK and many other countries. The limit for storage vessels in the UK is 2 parts per million; any properly fired lead bisilicate or lead sesquisilicate glaze should be well within this. Your pottery supply house should be able to tell you the details for your country, and where tests can be carried out. In the UK, Ceram in Stoke-On-Trent can test glazes for you (Ceram, Queen's Road, Penkhull, Stoke-on-Trent ST4 7LQ, Tel: 01782 764428, Web: www.ceram.com).

Websites

Organisations and Galleries

Art in Action www.artinaction.org.uk
A wonderful show in which all the participants, as well as exhibiting, either demonstrate or teach.

Art in Clay www.artinclay.co.uk
The National Ceramics Fetival held in August each year, with a smaller sister show in Farnham every November.

Ceramic Review www.ceramicreview.com

Charles Rennie Mackintosh House & Galleries www.78derngate.org.uk

Ellen Rijsdorp's gallery www.bisqceramics.nl

Goldmark Gallery www.modernpots.com
Outstanding exhibitions of leading potters, including Clive Bowen, each accompanied by a fully illustrated monograph.

Oakwood Ceramics www.oakwoodceramics.co.uk
The leading on-line gallery in the UK, lovingly curated by David Binch.

Peter Buckland Gallery www.peterbucklandgallery.ca
Features some potters and many painters.

St Ives Ceramics www.st-ives-ceramics.co.uk

Studio Pottery www.studiopottery.co.uk
UK's leading website for potters and those interested in ceramics, featuring many individual potters as well as events, courses and galleries etc.

YouTube www.youtube.com
You can forget time and get lost in YouTube, forfeiting weeks of your life – but there are some videos worth watching. Simon Leach decorating tea-bowls with hakeme is one.

John Edgeler's books are available from www.cotswoldliving.co.uk

Artist's Individual & Group Websites

Alice Ballard www.aliceballard.com

David Cooke www.sculpturelounge.com

Douglas Fitch www.douglasfitch.co.uk

Ellen Rijsdorp www.kruithuis.nl

Françoise Dufayard http://dufayard.ceramics.over-blog.com

Graham Hudson www.grahamhudson-ceramics.co.uk

Jenny Mendes www.jennymendes.com

Jim Malone www.jimmalonepottery.co.uk

John and Jude Jelfs www.cotswoldpottery.co.uk

John Mathieson www.studiopottery.co.uk

John Pollex www.johnpollex.co.uk

Leach Pottery www.leachpottery.com

Lisa Hammond www.greenwichgateway.com/mazehill

Lynda Harris www.nzpotters.com

Mirka Golden-Hann www.claystone.co.uk

Nic Collins www.nic-collins.co.uk

Rachel Wood www.studiopottery.co.uk

Rebecca Harvey www.rebeccaharvey.f9.co.uk

Reuben Batterham www.batterham.net

Richard Phethean www.phethean.clara.net

Roger Dalrymple www.rogerdalrymple.com

Ron Philbeck www.ronphilbeckpottery.com

Ross Emerson www.rossemerson.co.uk

Sasha Wardell www.sashawardell.com

Steven Branfman www.americanpotters.com

Tim Andrews www.timandrewsceramics.co.uk

Yo Thom www.yothom.com

Bibliography

Tim Andrews – *Raku* (2nd edition) (A&C Black, London, 2005).

David Barker & Steve Crompton – *Slipware in the Collection of The Potteries Museum & Art Gallery* (A&C Black, London, 2007).

Steven Branfman – *Mastering Raku: Making Ware – Glazing – Building Kilns – Firing* (Lark Books, New York, 2009).

Steven Branfman – *The Potters Professional Handbook* (Krause Publications, Iola WI, 1999, American Ceramic Society, Westerville OH, 2003).

Steven Branfman – *Raku, a Practical Approach* (Chilton Books, Radnor PA, 1991; A&C Black, London, 1991; 2nd edition, Krause Publications, Iola WI, 2001; German-language edition; Hanusch Verlag, Koblenz, 2002).

The Ceramic Book (the fully illustrated directory of the Craft Potters' Association of Great Britain), edited by Emmanuel Cooper (Ceramic Review Publishing, London, 2008).

Michael Cardew – *A Pioneer Potter* (Oxford University Press, 1989).

Michael Cardew and Pupils (York City Art Gallery, 1983).

Sidney B. Cardozo & Masaaki Hirano – *Uncommon Clay, The Life and Pottery of Rosanjin* (Kodansha International, Tokyo, 1987).

Garth Clark – *Michael Cardew* (Faber and Faber, London, 1978).

Rosemary Cochrane – *Salt-Glaze Ceramics* (The Crowood Press, Marlborough, UK, 2001).

Ronald G. Cooper – *English Slipware Dishes 1600–1850* (Tiranti, London, 1968).

Mike Dodd – *An Autobiography of Sorts* (Canterton Books, Brook, Hampshire, 2004).

Victoria & Michael Eden – *Slipware – Contemporary Approaches* (A&C Black, London, 1999).

John Edgeler – *Ray Finch, Craftsman Potter of the Modern Age* (Cotswolds Living Publications, Winchcombe, UK, 2006).

John Edgeler – *Michael Cardew and the West Country Slipware Tradition* (Cotswolds Living Publications, Winchcombe, UK, 2007).

John Edgeler – *Michael Cardew and Stoneware – Continuity and Change* (Cotswolds Living Publications, Winchcombe, UK, 2008).

John Edgeler – *The Fishleys of Fremington – A Devon Slipware Tradition* (Cotswolds Living Publications, Winchcombe, UK, 2008).

John Edgeler – *Slipware and St. Ives –* (Cotswold Living Publications, Winchcombe, UK, 2010).

Ron Wheeler and John Edgeler – *Sid Tustin – Winchcombe Potter* (Cotswold Living Publications, Winchcombe, UK, 2005).

500 Plates & Chargers (Lark Books, New York, 2008).

Goldmark Gallery Monographs – including Clive Bowen (2006), essential for anyone interested in slipware (see Websites for contact details).

Frank & Janet Hamer – *The Potter's Dictionary of Materials and Techniques* (5th edition) (A&C Black, London, 2004).

Andrew Holden – *The Self-Reliant Potter* (A&C Black, London, 1982).

David Jones – *Firing – Philosophies Within Contemporary Ceramic Practice* (The Crowood Press, Marlborough, UK, 2007).

John Mathieson – *Raku* (A&C Black Ceramics Handbooks, London, 2002).

Jane Perryman – *Smoke-fired Pottery* (A&C Black, London, 1995).

Jane Perryman – *Naked Clay – Ceramics Without Glaze* (A&C Black, London, 2004).

Susan Peterson – *The Living Tradition of Maria Martinez* (Kodansha International, Tokyo, 1977).

Richard Phethean – *The Complete Potter – Throwing* (Batsford, London, 1993).

John Pollex – *Slipware* (Pitman, London 1979)

Phil Rogers – *Salt Glazing* (A&C Black, London, 2002).

Brian Sutherland – *Glazes from Natural Sources* (A&C Black, London 2005)

Jane Waller – *Hand-built Ceramics* (Batsford, London, 1990).

Josie Walter – *Pots in the Kitchen* (The Crowood Press, Marlborough, UK, 2002).

Sasha Wardell – *Porcelain and Bone China* (The Crowood Press, Marlborough, UK, 2004).

Sasha Wardell – *Slipcasting* (2nd Edition) (A&C Black, London, 2007).

Mary Wondrausch – *Mary Wondrausch on Slipware*, (2nd edition) (A&C Black, London, 2001).

Soetsu Yanagi – *The Unknown Craftsman* (Kodansha International, Tokyo, 1972).

Suppliers

UK

Bath Potters' Supplies
Unit 18, Fourth Avenue
Westfield Trading Estate
Radstock, Bath
BA3 4XE
Tel: 01761 411077
Fax: 01761 414115
Email: sales@bathpotters.co.uk
www.bathpotters.co.uk

CTM Potters' Supplies
Unit 10A, Mill Park Industrial Estate
White Cross Road
Woodbury Salterton
EX5 1EL
Tel: 01395 233077
Fax: 01395 233905
Email: admin@ctmpotterssupplies.co.uk
www.ctmpotterssupplies.co.uk

Laser Kilns Limited
Unit C9, Angel Road Works
Advent Way
London
N18 3AH
Tel: 020 8803 1016
Fax: 020 8807 2888
Email: sales@laser-kilns.co.uk
www.laser-kilns.co.uk

Medcol (Cornwall) Limited
17 Woods Browing Industrial Estate
Bodmin
Cornwall
PL31 1DQ
Tel: 01208 72260
Fax: 01208 78012
Email: medcolcwll@aol.com
www.kilns-wheels.co.uk

Potclays Limited
Brick Kiln Lane
Etruria
Stoke-on-Trent
ST4 7BP
Tel: 01782 219816
Fax: 01782 286506
Email: sales@potclays.co.uk
www.potclays.co.uk

Potterycrafts Limited
Campbell Road
Stoke-on-Trent
ST4 4ET
Tel: 01782 745000
Fax: 01782 746000
Email: sales@potterycrafts.co.uk
www.potterycrafts.co.uk

Scarva Pottery Supplies
Unit 20, Scarva Road Industrial Estate
Banbridge, Co. Down
BT32 3QD
Tel: 028 406 69699
Fax: 028 406 69700
Email: david@scarvapottery.com
www.scarvapottery.com

Top Pot Supplies
Celadon House
8 Plough Lane, Newport
Shropshire
TF10 8BS
Tel: 01952 813203
Fax: 01952 810703
Email: robin@toppot.co.uk
www.toppotsupplies.co.uk

Valentine Clays Limited
The Sliphouse
18–20 Chell Street, Hanley
Stoke-on-Trent
ST1 6BA

Tel: 01782 271200
Fax: 01782 280008
Email: sales@valentineclays.co.uk
www.valentineclays.co.uk

W.J Doble Pottery Clays
Newdowns Sand & Clay Pits
St Agnes
Cornwall
TR5 0ST
Tel: 01872 552979

USA & Canada

Amaco
6060 Guion Road
Indianapolis
IN 46254-1222
Tel: (01) 800 374 1600
www.amaco.com

Axner
490 Kane Court
Oviedo
FL 32765
Tel: (01) 407 365 2600
www.axner.com

Columbus Clay
1080 Chambers Road
Columbus
OH 43212
Tel: (01) 866 410 2529
www.columbusclay.com

Highwater Clays
600 Riverside Drive
Asheville
NC 28801
Tel: (01) 828 252 6033
www.highwaterclays.com

Kemper Tools
13595 12th Street
Chino, CA 91710
Tel: 909 627 6191
Fax: 909 627 4008
Email: customerservice@kempertools.com
www.kempertools.com

Laguna Clay
14400 Lomitas Avenue
City of Industry
CA 91746
Tel: (01) 800 452 4862
Fax: (01) 626 333 7694
Email: info@lagunaclay.com
www.lagunaclay.com

Mile Hi Ceramics Inc.
77 Lipan
Denver
CO 80223
Tel: (01) 303 825 4570
www.milehiceramics.com

Minnesota Clay Co.
8001 Grand Avenue South
Bloomington, MN 55420
Tel: (01) 612 884 9101
www.minnesotaclayusa.com

Tuckers Pottery Supplies Inc.
15 West Pearce Street
Richmond Hill
Ontario
Canada
L4B1 H6
Tel: (01) 800 304 6185
www.tuckerspottery.com

Index

Teapot by Richard Phethean. (h. 28 cm/11 in.), thrown and distorted with slab and coil additions, wax resist, honey glaze. PHOTOGRAPH BY JOHN MATHIESON.